THESE COLORS DON'T RUN

A CELEBRATION OF THOSE WHO HAVE SERVED

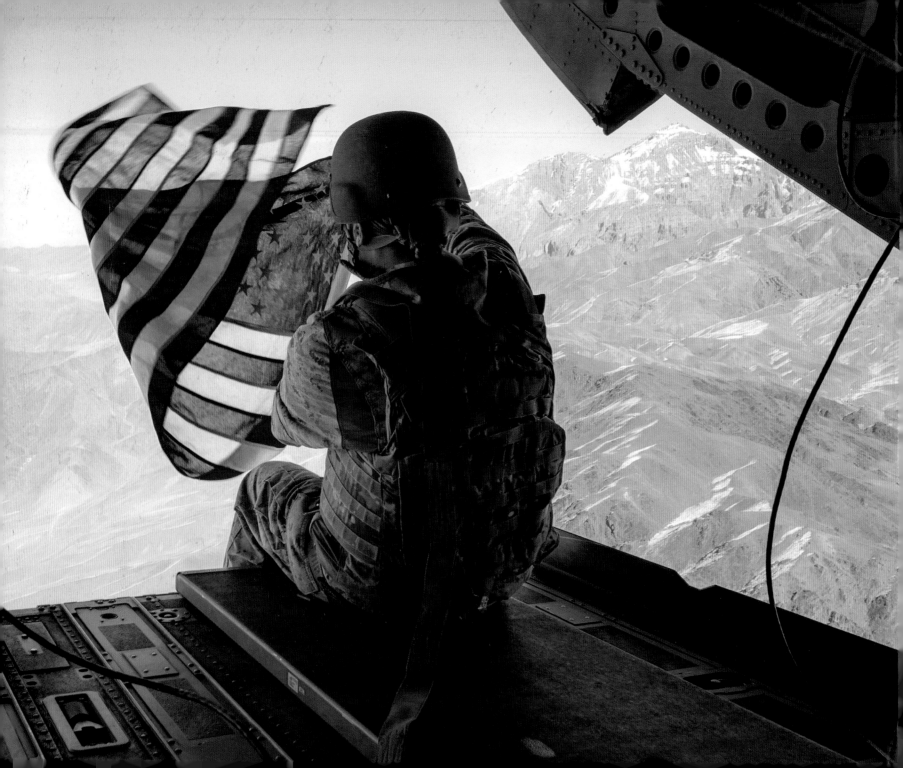

THESE COLORS DON'T RUN

A CELEBRATION OF THOSE WHO HAVE SERVED

EDITED BY **MARY ZAIA**

CASTLE POINT BOOKS
NEW YORK

www.castlepointbooks.com

The Castle Point Books trademark is owned by Castle Point Publishing, LLC.
Castle Point books are published and distributed by St. Martin's Press.

ISBN 978-1-250-27211-9 (hardcover)
ISBN 978-1-250-27212-6 (ebook)

Design by Joanna Williams

Our books may be purchased in bulk for promotional, educational, or business use.
Please contact your local bookseller or the Macmillan Corporate and Premium Sales Department
at 1-800-221-7945, extension 5442, or by email at MacmillanSpecialMarkets@macmillan.com.

First Edition: September 2020

10 9 8 7 6 5 4 3 2 1

CONTENTS

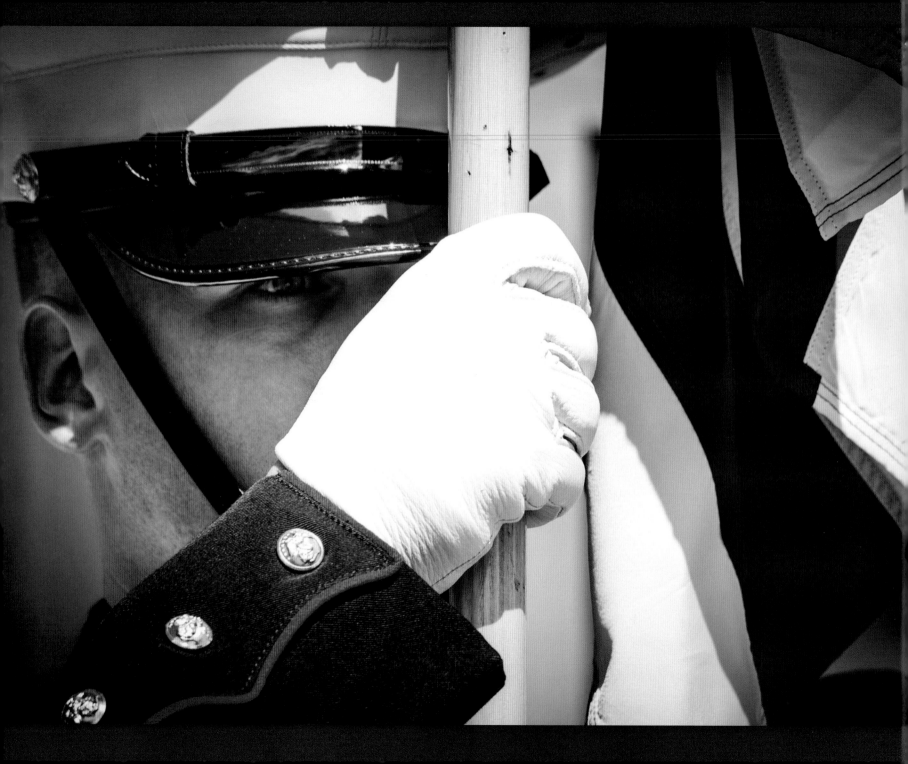

SERVING A GREATER GOOD

Service to country: three words that express a life-changing promise. Answering the country's call to military service requires the highest levels of character and valor, from civic missions and peacekeeping work to overseas deployment and live combat. It requires uncommon strength and sacrifice, leaving behind loved ones and the comforts of a civilian life. It demands acceptance of every challenge presented, often in unimaginable conditions, with the selfless goal of protecting country, family, friends, and freedom.

But just as the ask is great, so too is the reward—the pride that comes with knowing so many enjoy peace and opportunity because of the sacrifices made by those who serve. *These Colors Don't Run* celebrates that commitment and the enduring values of the U.S. military: loyalty, duty, respect, honor, integrity, and courage. Each page pays photographic tribute to the men and women of our Armed Forces, who choose country over self day after day, and who truly make America great. *These Colors Don't Run* is a reminder of the power we have within us when we come together to fight for a greater cause.

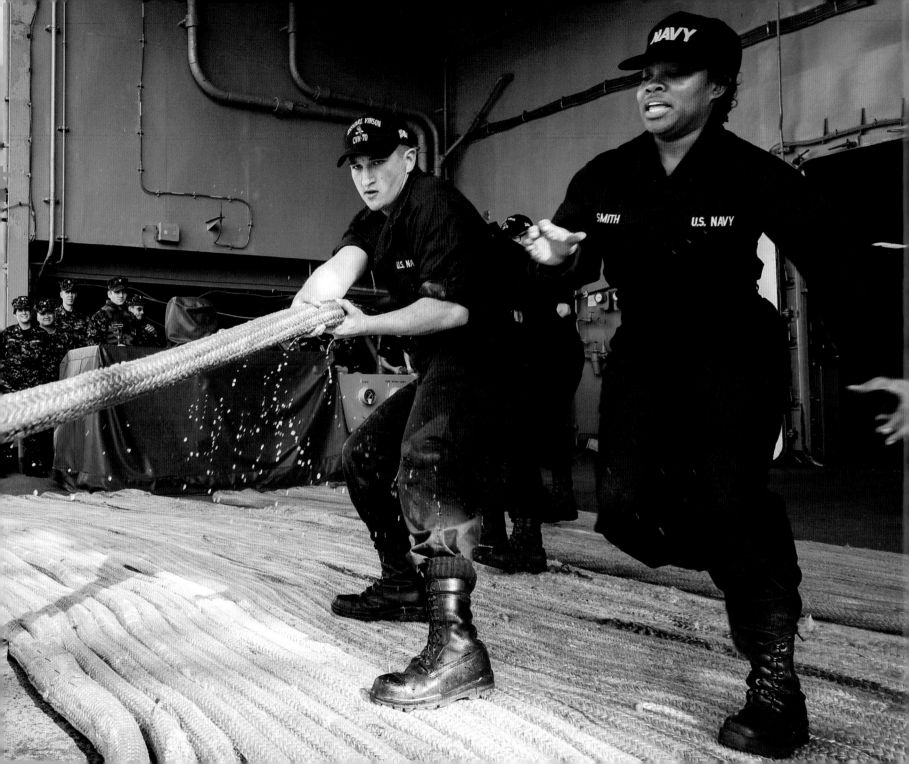

★ UNCOMMON STRENGTH ★

It is a proud privilege
to be a good soldier [with] discipline,
**SELF-RESPECT, PRIDE IN
UNIT AND COUNTRY,**
a high sense of duty
and obligation to comrades
and to superiors, and a
**SELF-CONFIDENCE BORN OF
DEMONSTRATED ABILITY.**

—GEORGE S. PATTON JR.

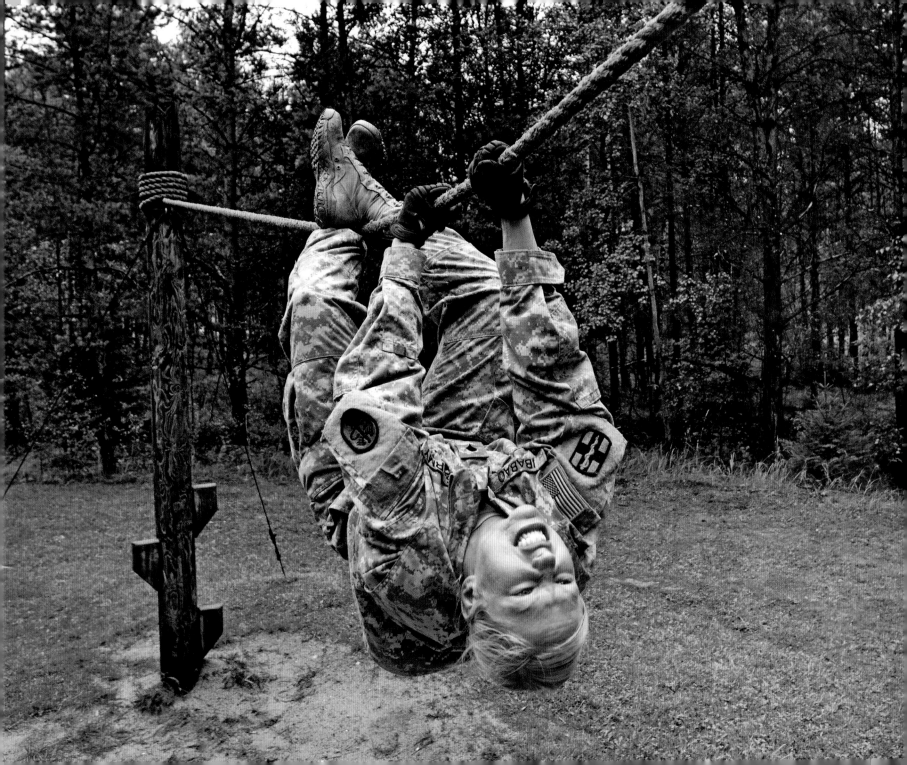

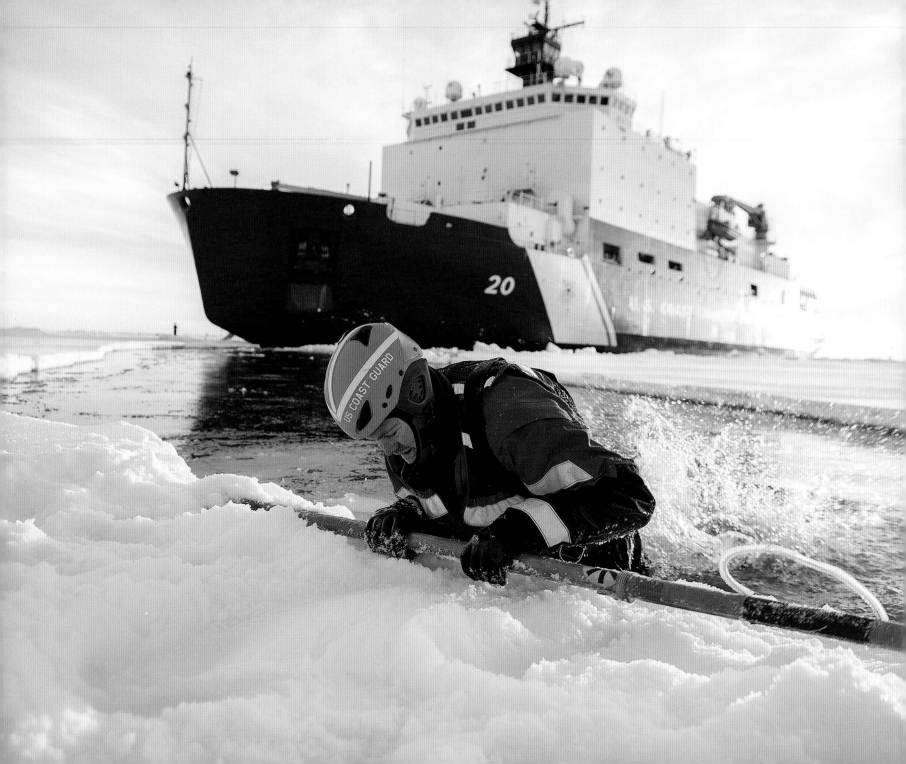

I DO NOT KNOW THE WORD "QUIT."
Either I never did, or I have abolished it.

—SUSAN BUTCHER

THE ONLY EASY DAY
WAS YESTERDAY.

—US NAVY SEALS

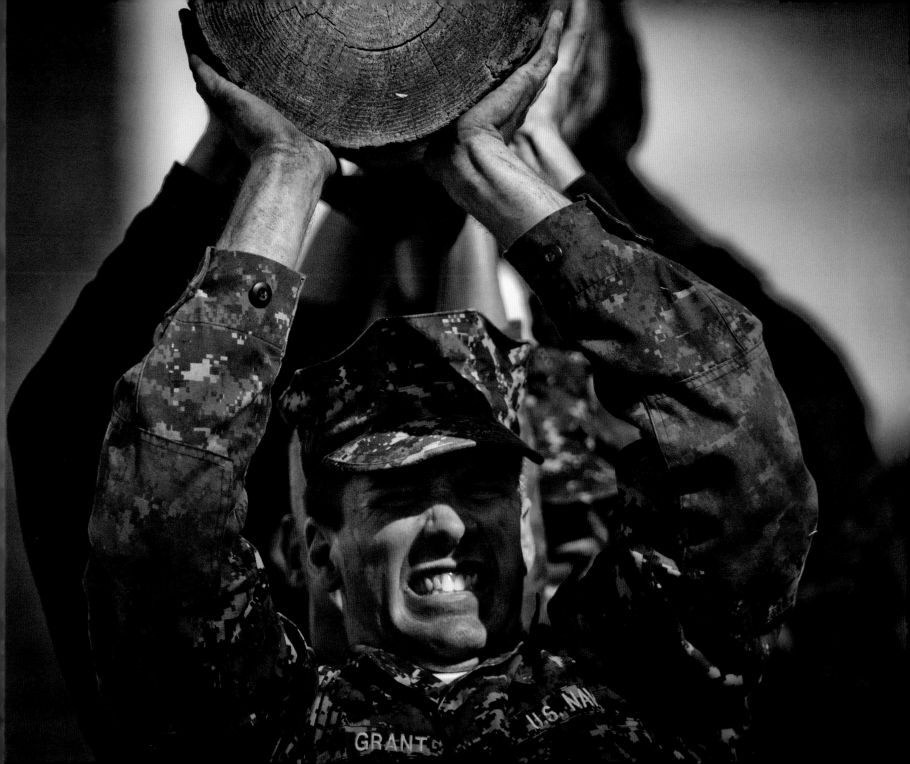

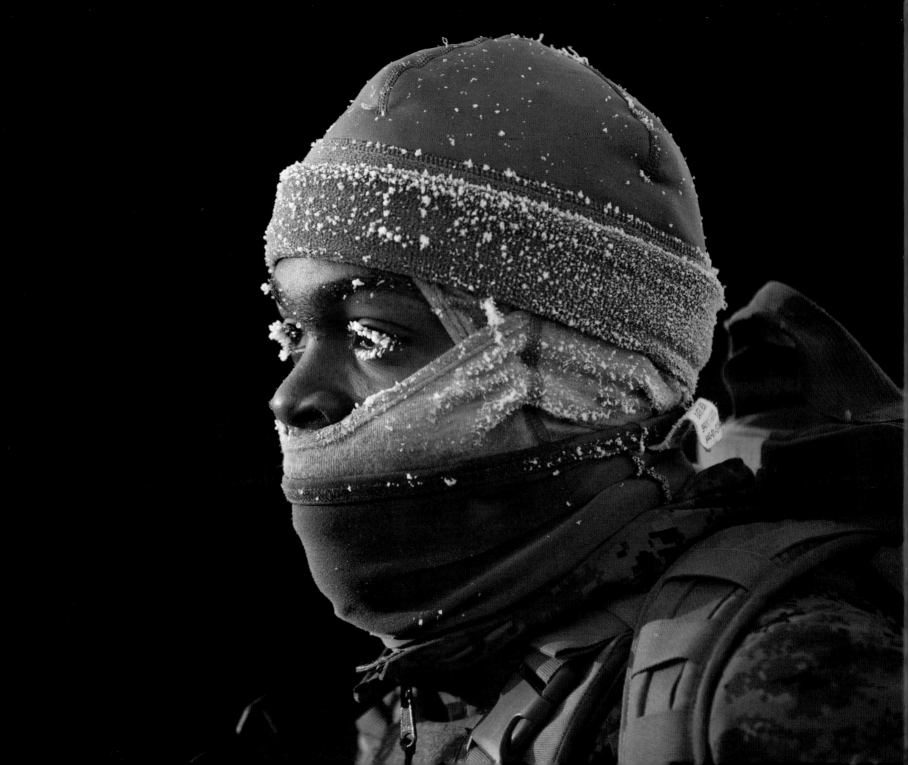

I will suffer through the bad
for the heights of the good.

—PAT TILLMAN

THERE'S NO QUITTING,
I can't have quit in me.

—LISA JASTER

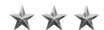

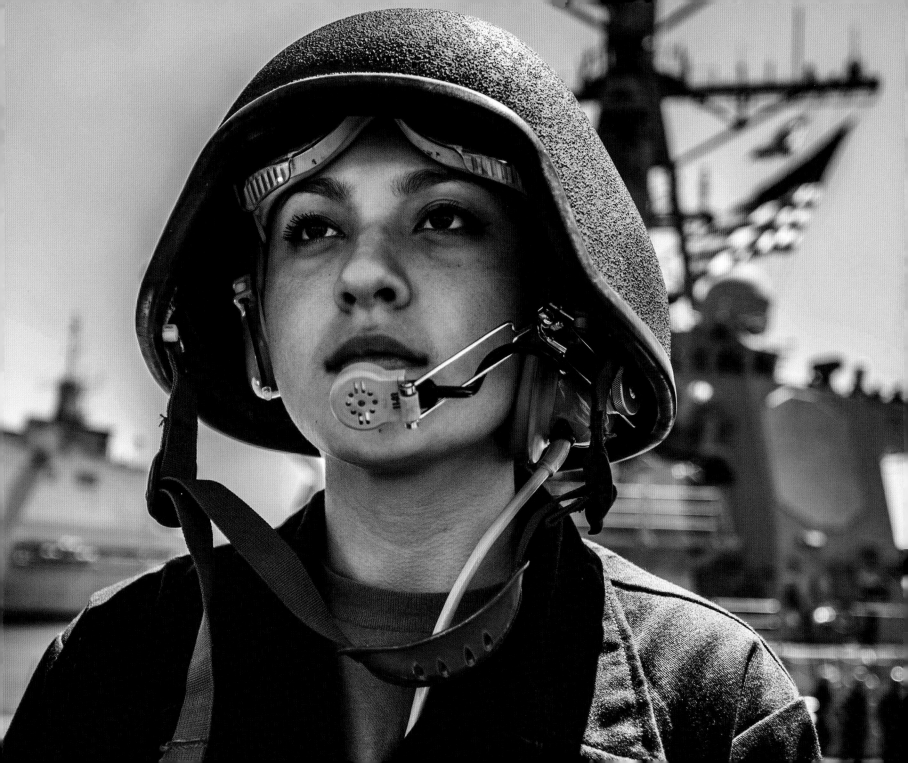

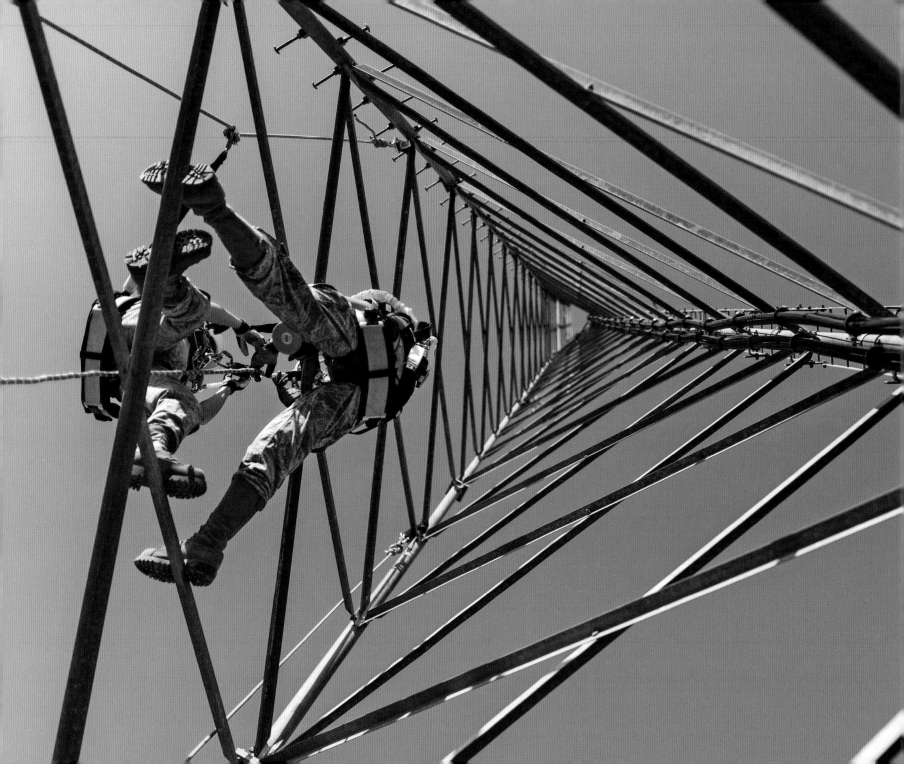

America was not built on fear.
America was built on courage,
on imagination, and an
unbeatable determination
to do the job at hand.

—HARRY TRUMAN

The history of free men
IS NEVER WRITTEN BY CHANCE
but by choice—their choice.

—DWIGHT D. EISENHOWER

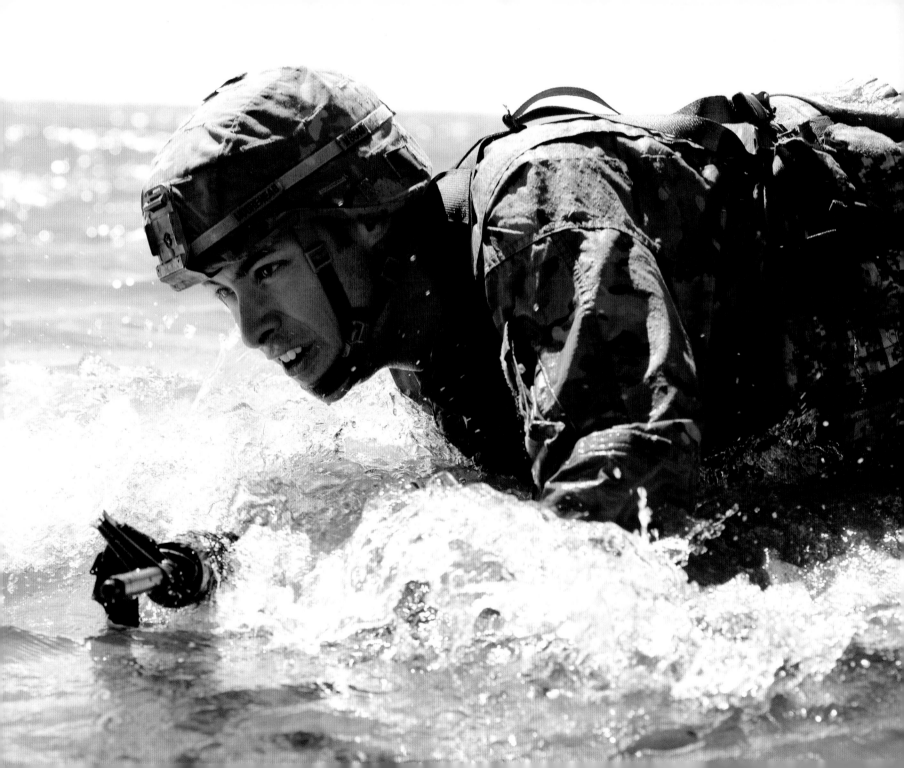

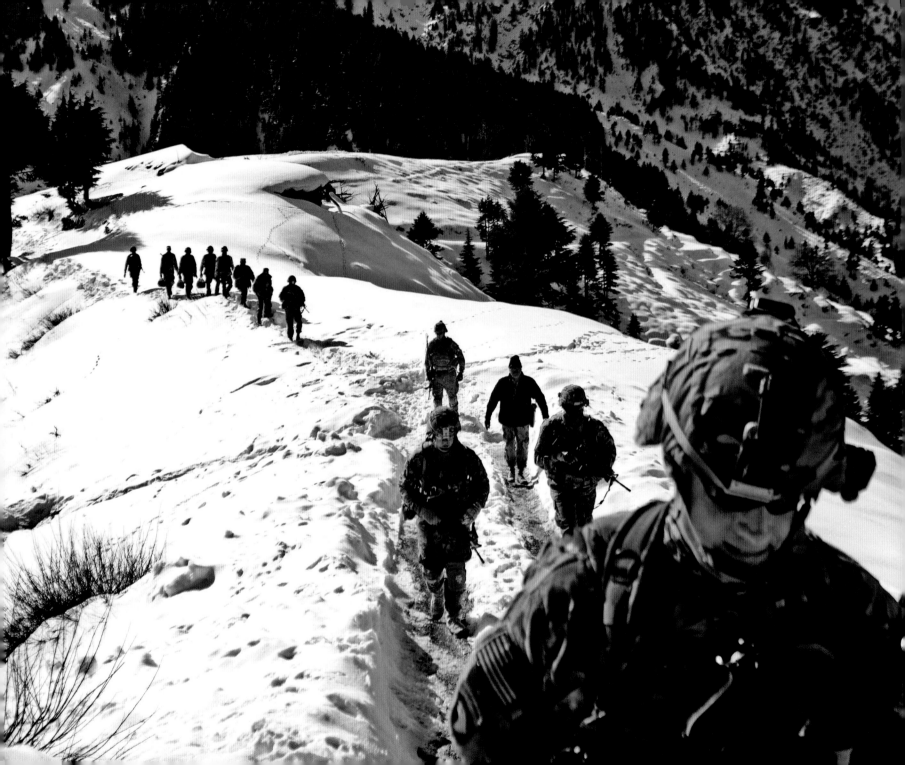

The man *on top of* the mountain didn't fall there.

—UNKNOWN

A hero is an ordinary individual
**WHO FINDS THE STRENGTH
TO PERSEVERE AND ENDURE**
in spite of overwhelming obstacles.

—CHRISTOPHER REEVE

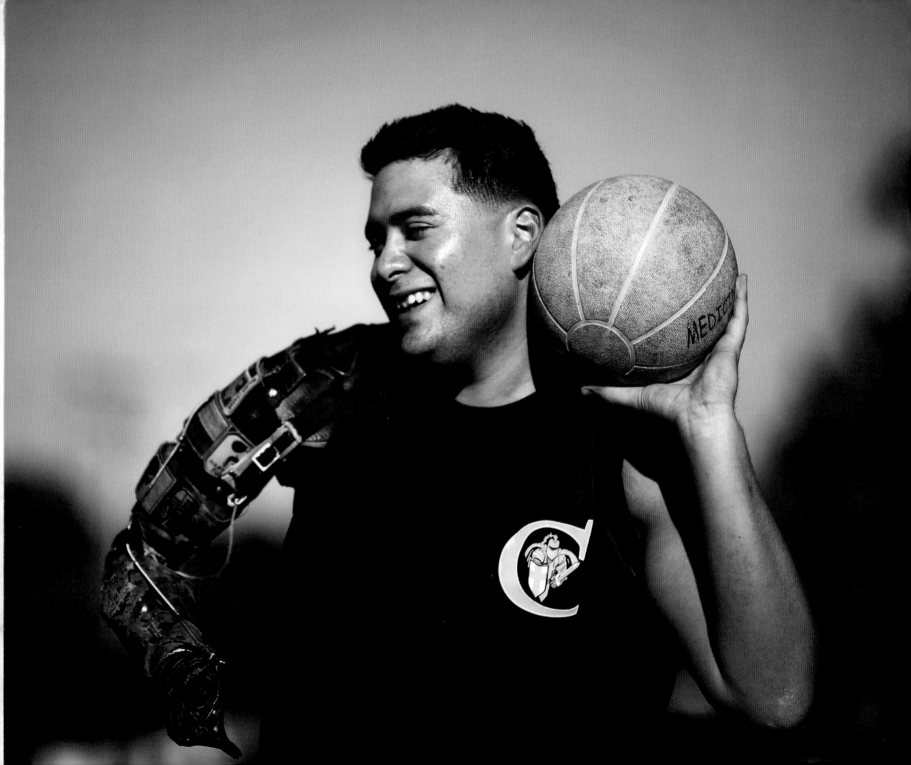

Every man is a vital link in the great chain.

—GEORGE S. PATTON JR.

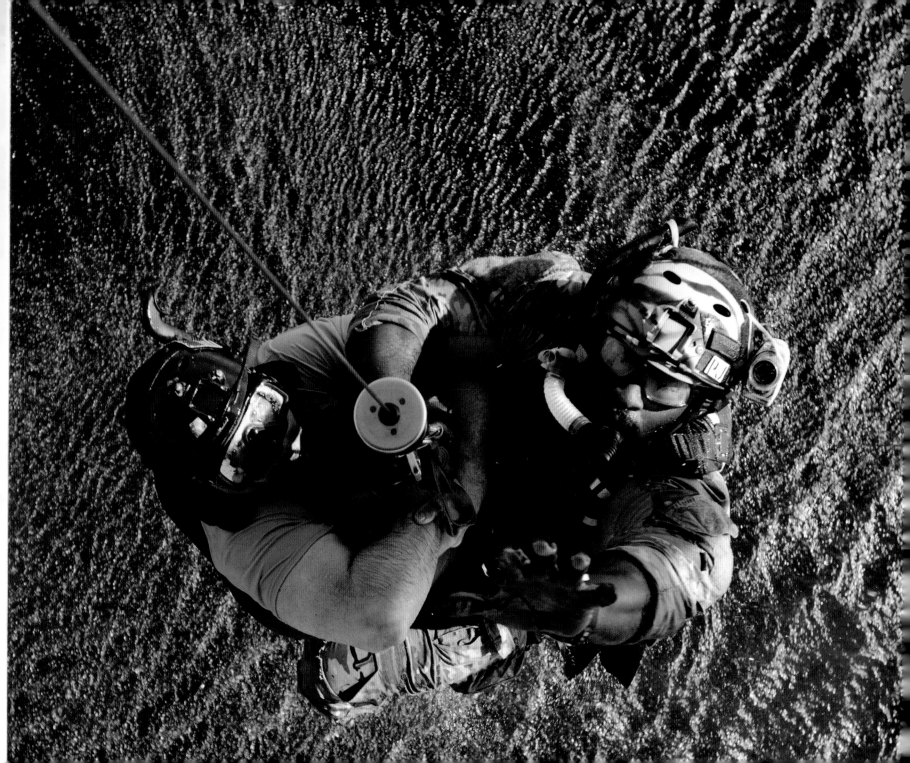

There is a certain enthusiasm in liberty, **THAT MAKES HUMAN NATURE RISE ABOVE ITSELF,** in acts of bravery and heroism.

—ALEXANDER HAMILTON

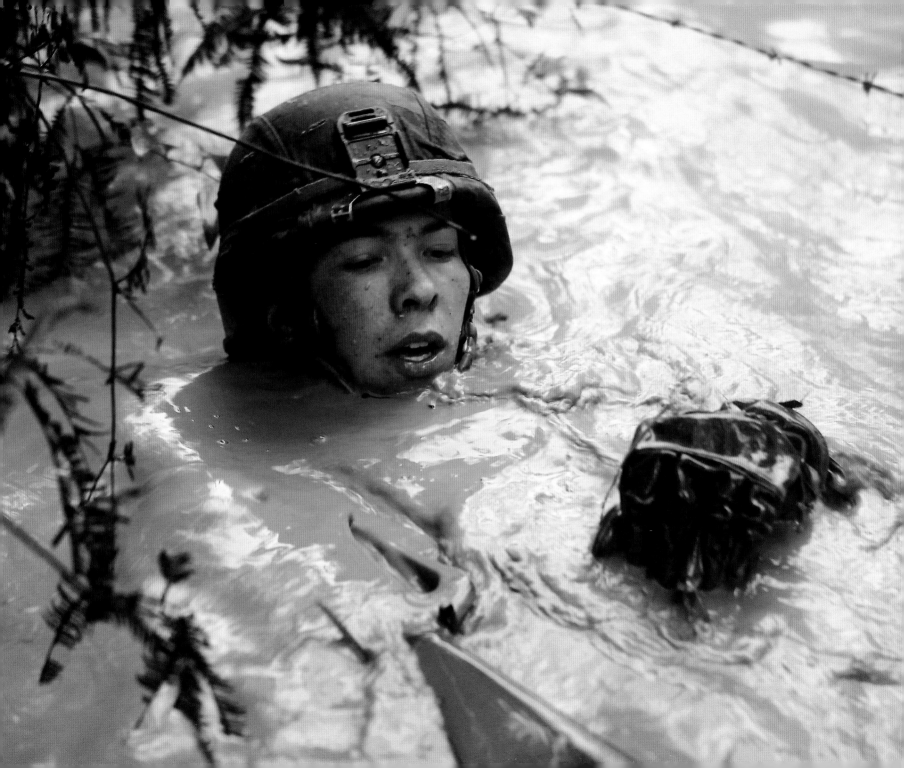

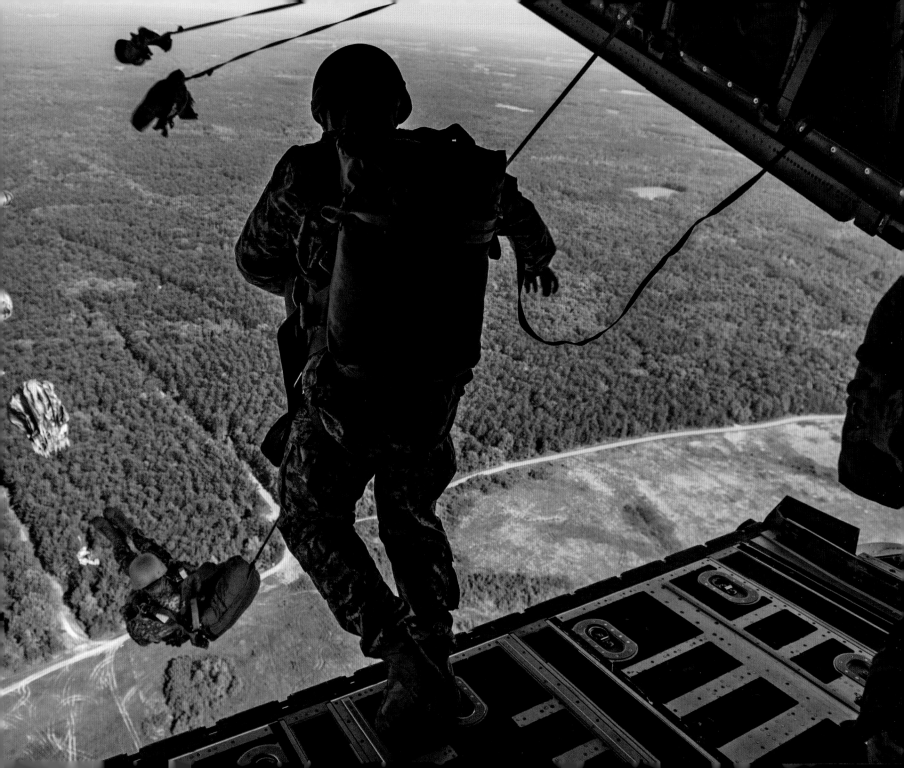

Our country's security doesn't depend
on the heroism of every citizen.
**But all of us should
be worthy of the sacrifices
made on our behalf.**

—JOHN McCAIN

America is not anything if it consists of each of us.

It is something only if it consists of all of us.

—WOODROW WILSON

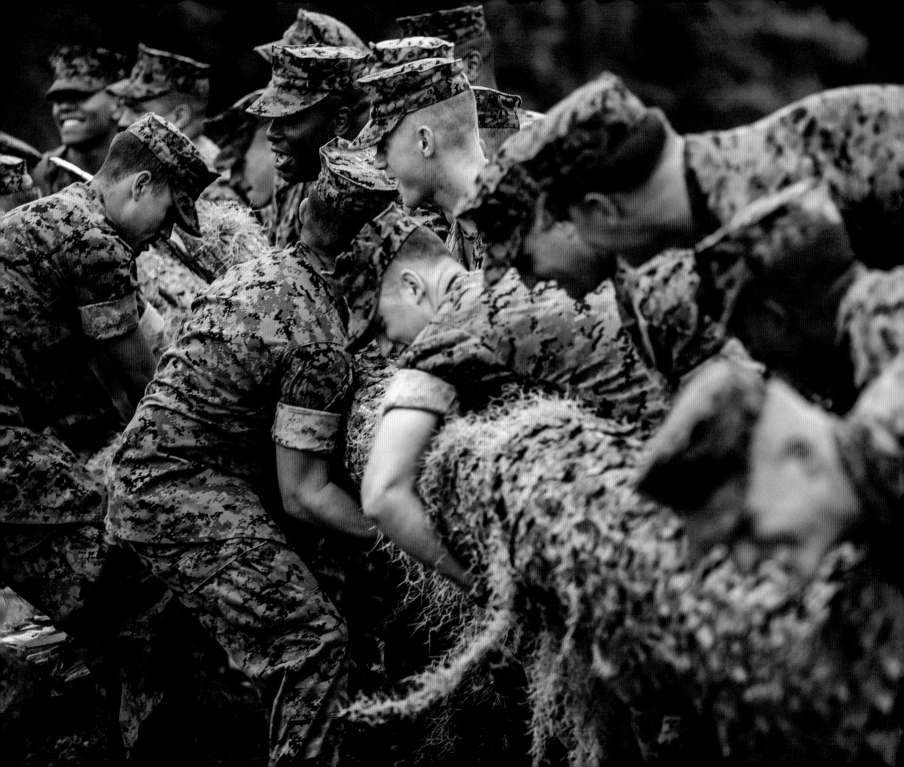

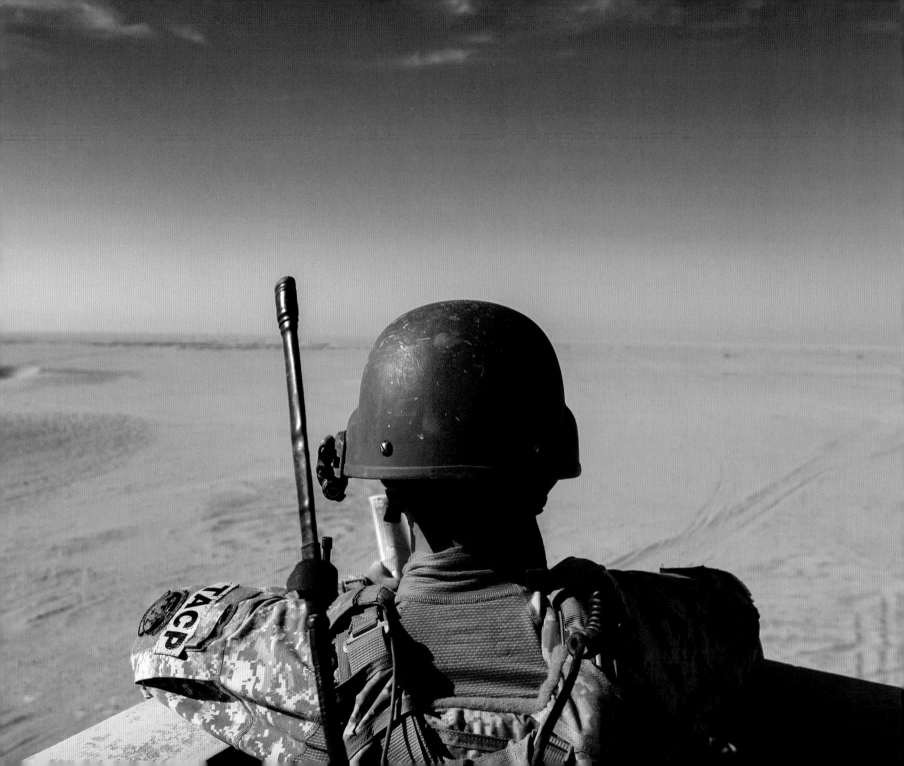

Patriotism is not a short and frenzied outburst of emotion **BUT THE TRANQUIL AND STEADY DEDICATION OF A LIFETIME.**

—ADLAI E. STEVENSON

The only thing we have to fear is fear itself.

–FRANKLIN D. ROOSEVELT

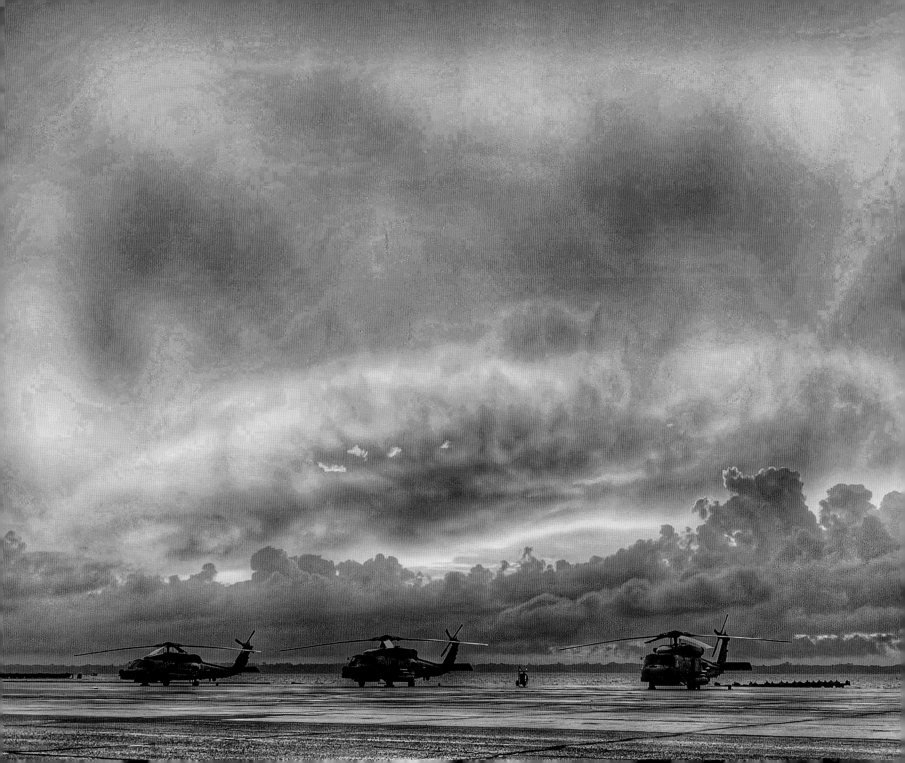

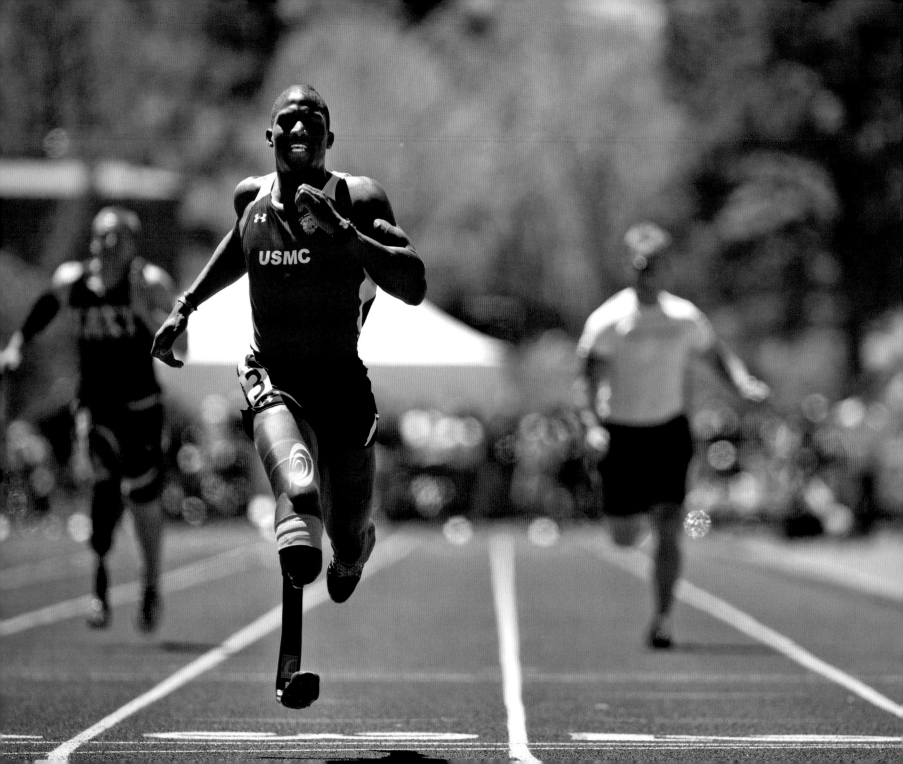

Courage and perseverance
HAVE A MAGICAL TALISMAN,
before which difficulties disappear and
OBSTACLES VANISH INTO AIR.

—JOHN QUINCY ADAMS

HONOR TO THE SOLDIER, AND SAILOR EVERYWHERE . . .
who braves, for the common good,
THE STORMS OF HEAVEN AND THE STORMS OF BATTLE.

—ABRAHAM LINCOLN

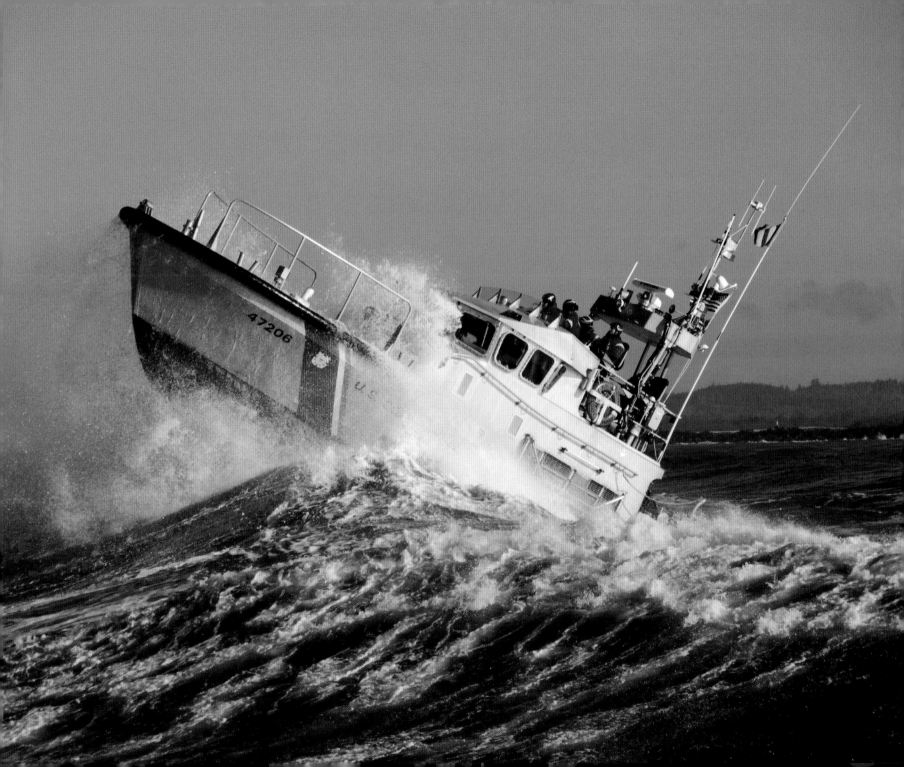

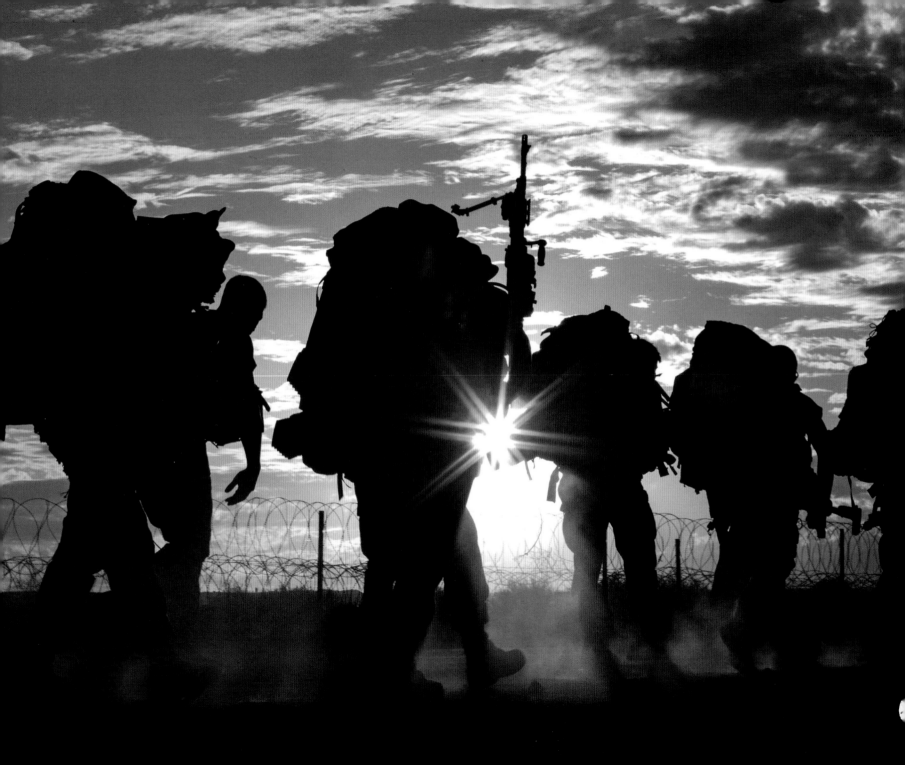

★ **COURAGE TO DEFEND** ★

Whenever and wherever
the nation has called—
IN TIMES OF DARKNESS
AND DANGER
as well as in times of
peace and prosperity—
AMERICA'S VETERANS
HAVE BEEN THERE.

—COLIN POWELL

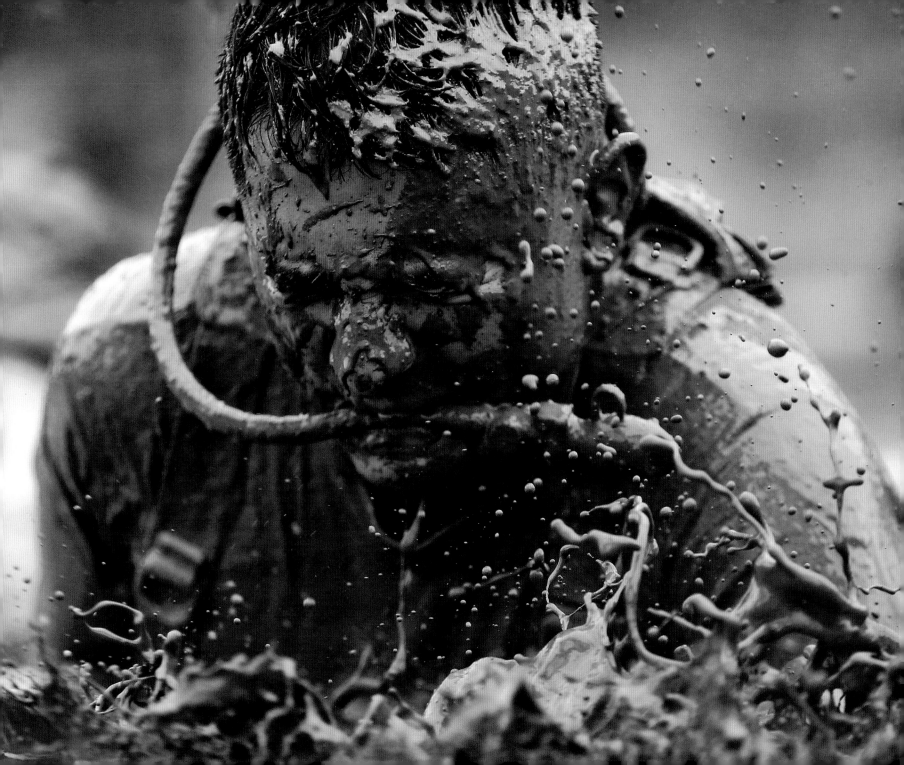

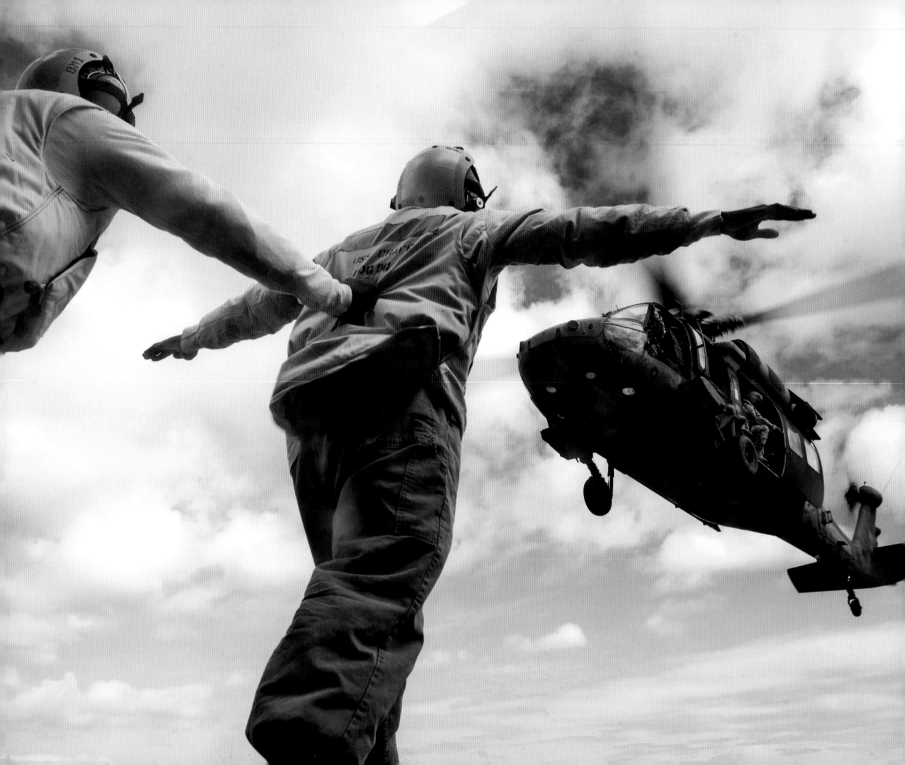

So much that is good in this nation depends on the unknown actions of humble men and women **who understand the importance of duty,** done without public recognition or the blare of trumpets.

—JIMMY CARTER

The true soldier fights
not because he hates
what is in front of him,
**BUT BECAUSE HE LOVES
WHAT IS BEHIND HIM.**

—G. K. CHESTERTON

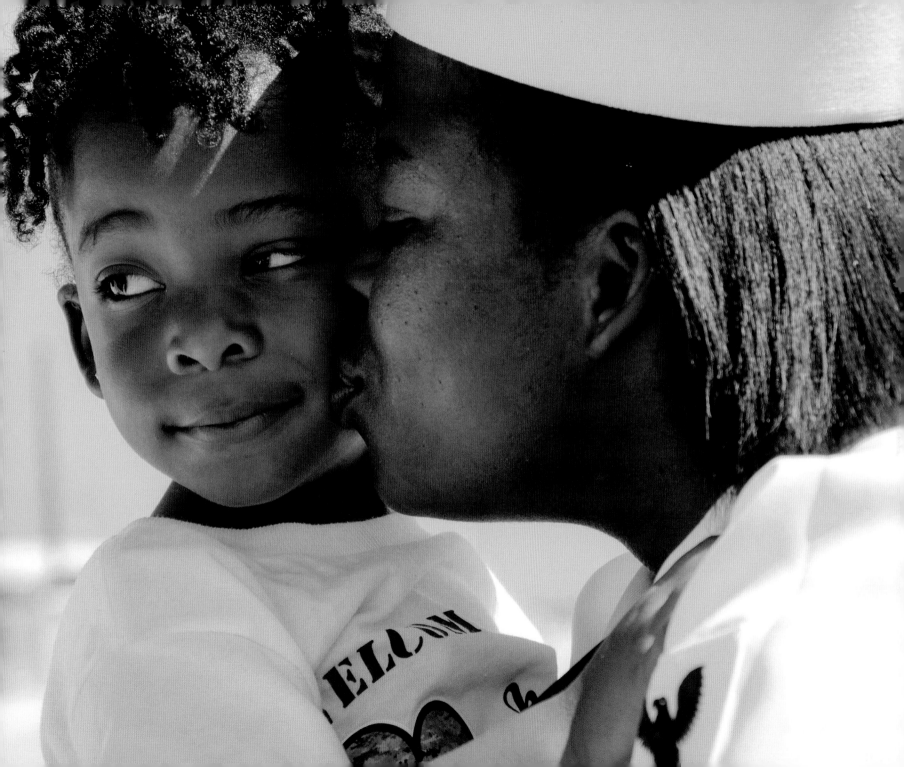

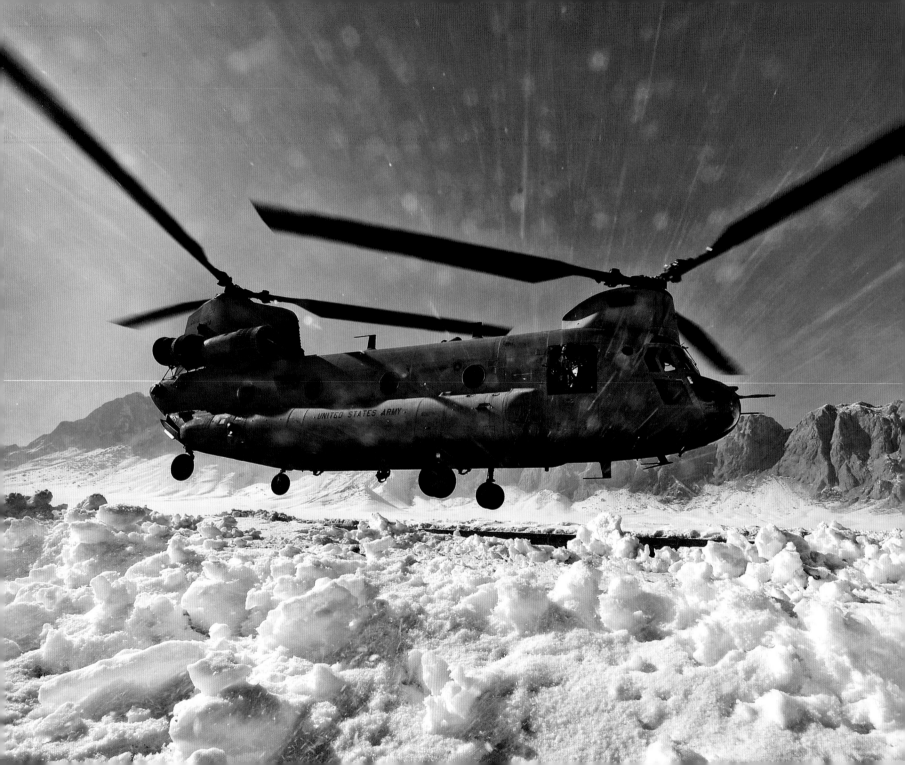

PEACE HAS ITS VICTORIES, but it takes brave men and women TO WIN THEM.

—RALPH WALDO EMERSON

WE FIGHT
so others can sleep
AT NIGHT.

—TIMOTHY CICIORA

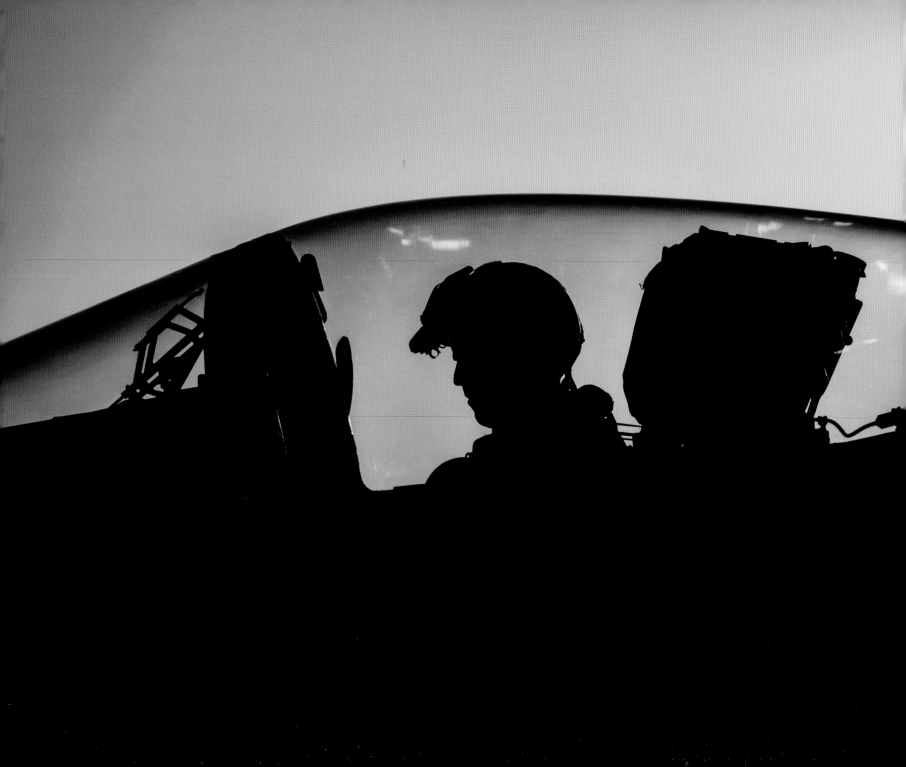

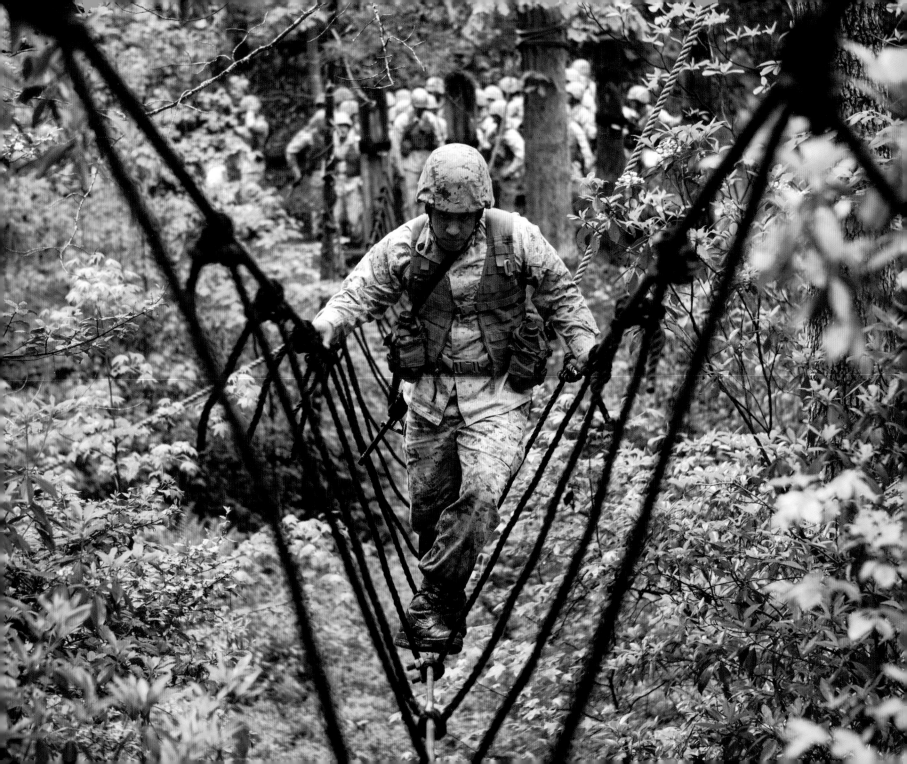

HISTORY DOES NOT LONG ENTRUST
the care of freedom to the weak or timid.

—DWIGHT D. EISENHOWER

Courage is not
the absence of fear but
**THE CAPACITY TO ACT
DESPITE OUR FEARS.**

—JOHN McCAIN

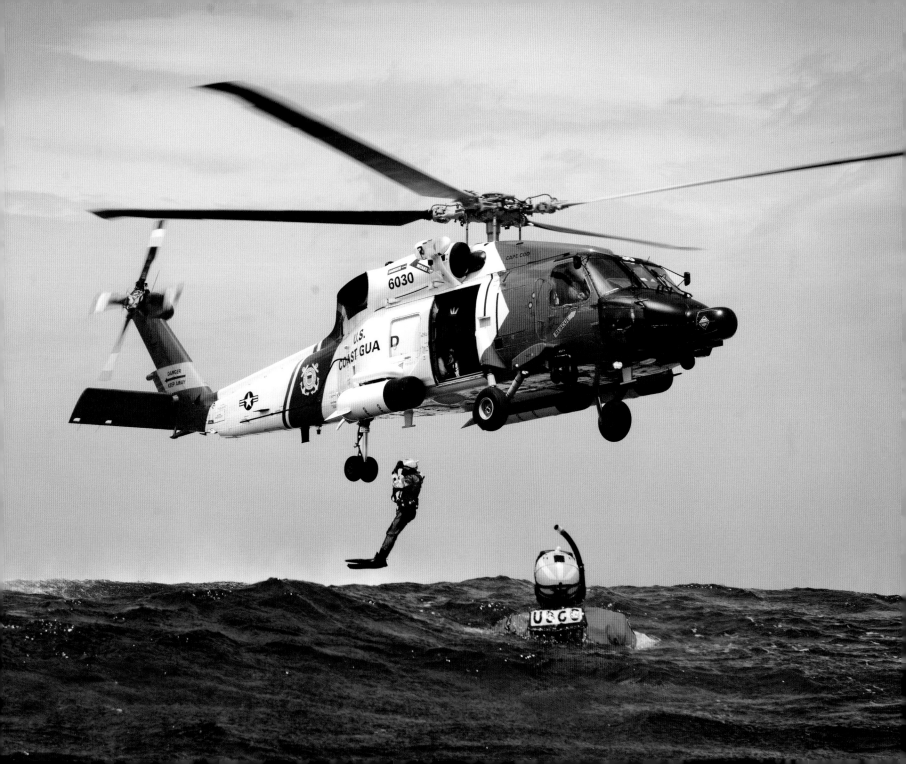

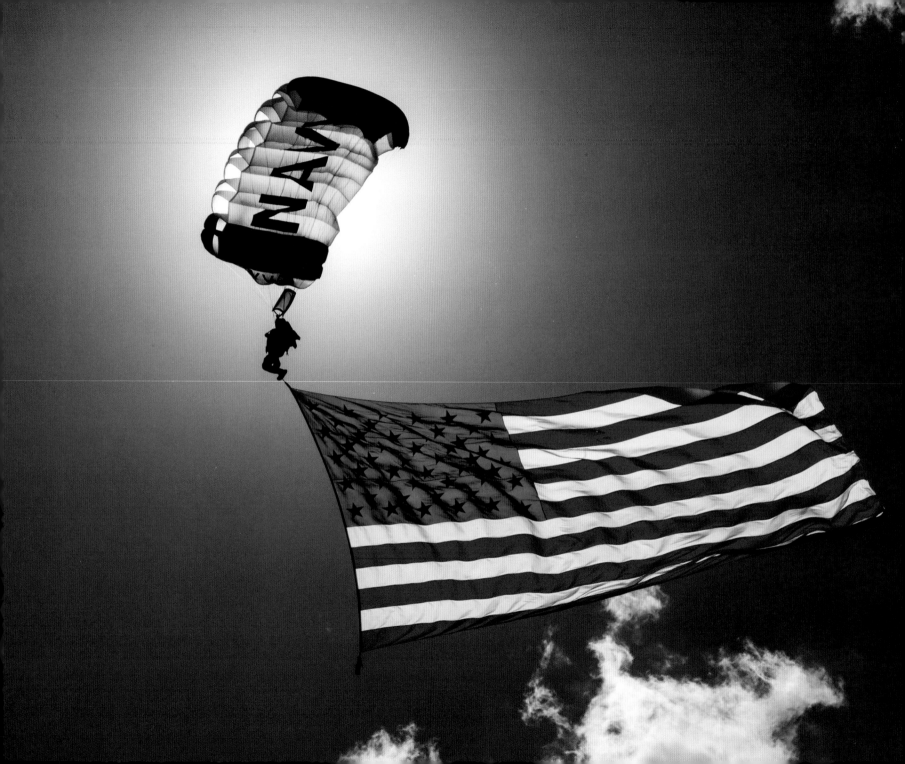

And the star-spangled banner
in triumph doth wave,

O'ER THE LAND OF THE FREE

AND THE HOME OF THE BRAVE!

—FRANCIS SCOTT KEY

With courage and character, *American soldiers continue to put themselves on the line* to defend our freedom.

—DAN LIPINSKI

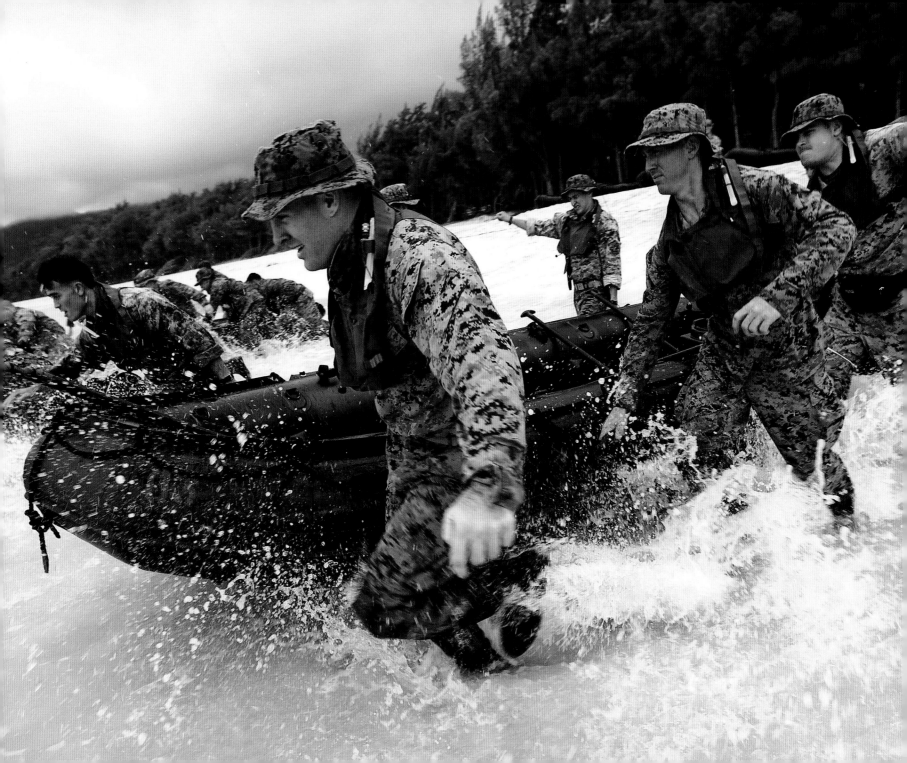

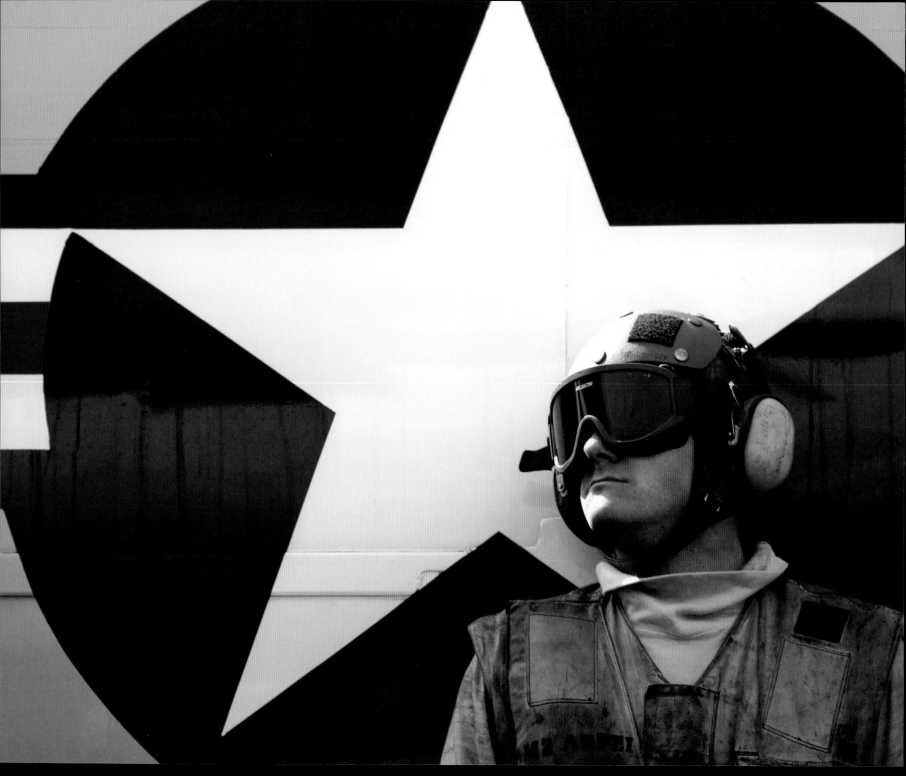

Each and every one of us
can sleep soundly at night,
*knowing we have
"guardians at the gate."*

—ALLEN WEST

FREEDOM LIES IN
BEING BOLD.

—ROBERT FROST

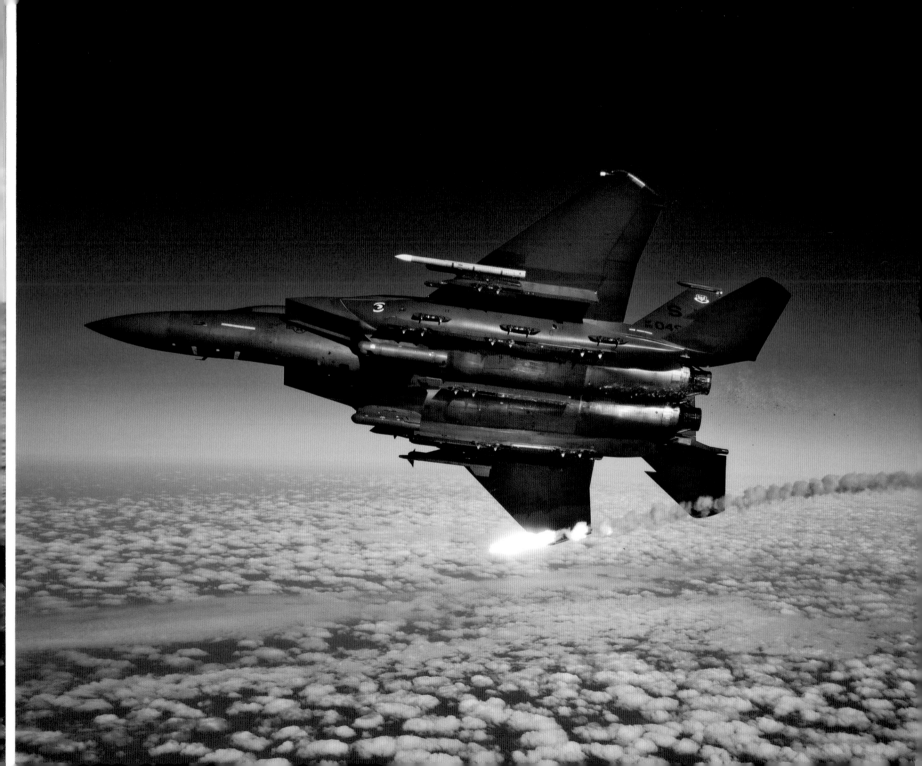

What counts is not necessarily the size of the dog in the fight—

it's the size of the fight in the dog.

—DWIGHT D. EISENHOWER

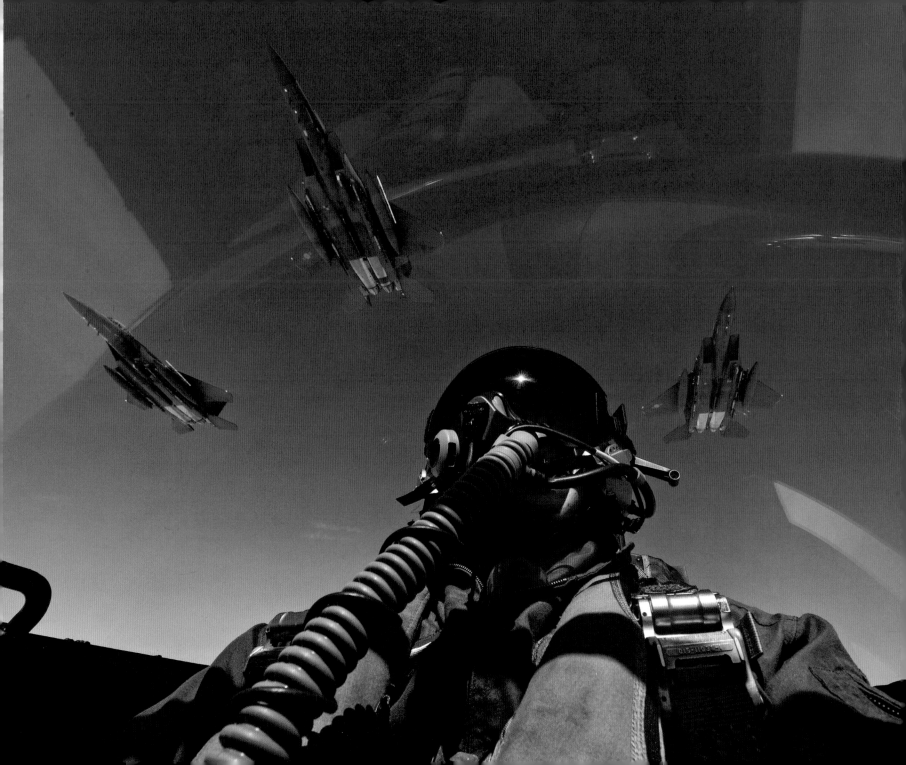

Courage is fear holding on a minute longer.

—GEORGE S. PATTON JR.

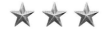

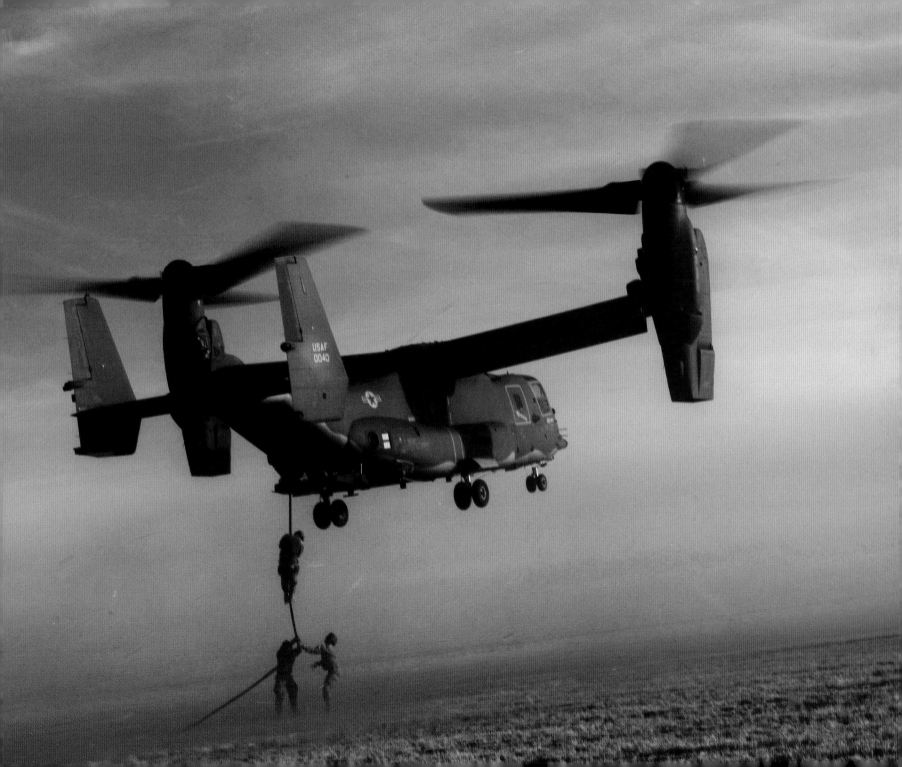

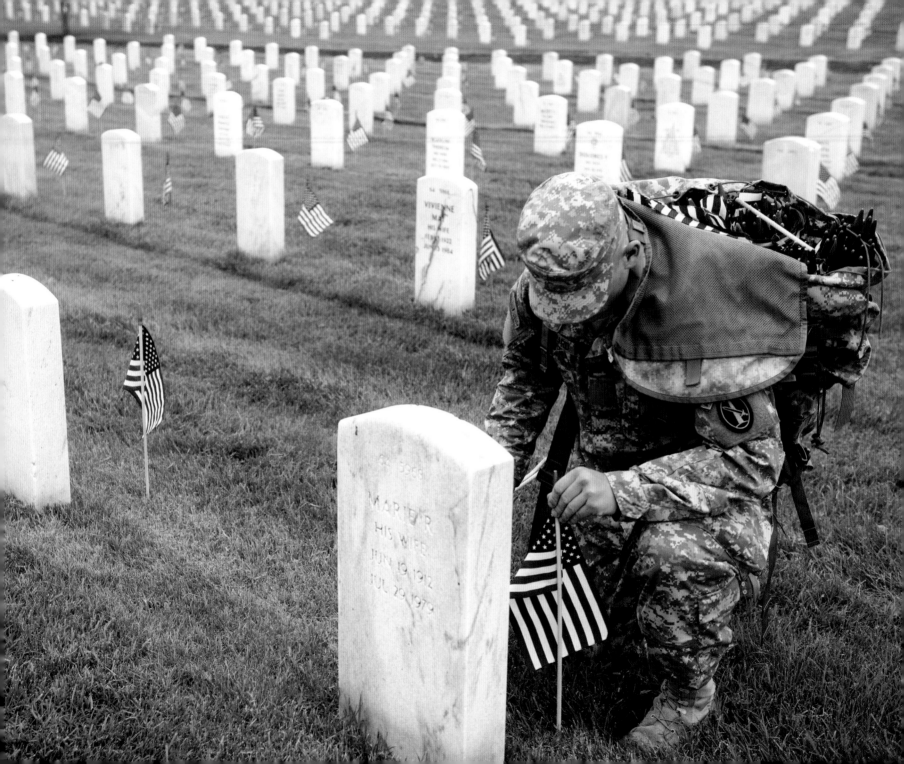

The brave die never,

though they sleep in dust:
Their courage nerves
a thousand living men.

—MINOT J. SAVAGE

NO MAN IS ENTITLED TO
the blessings of freedom
UNLESS HE BE VIGILANT
IN ITS PRESERVATION.

—DOUGLAS MacARTHUR

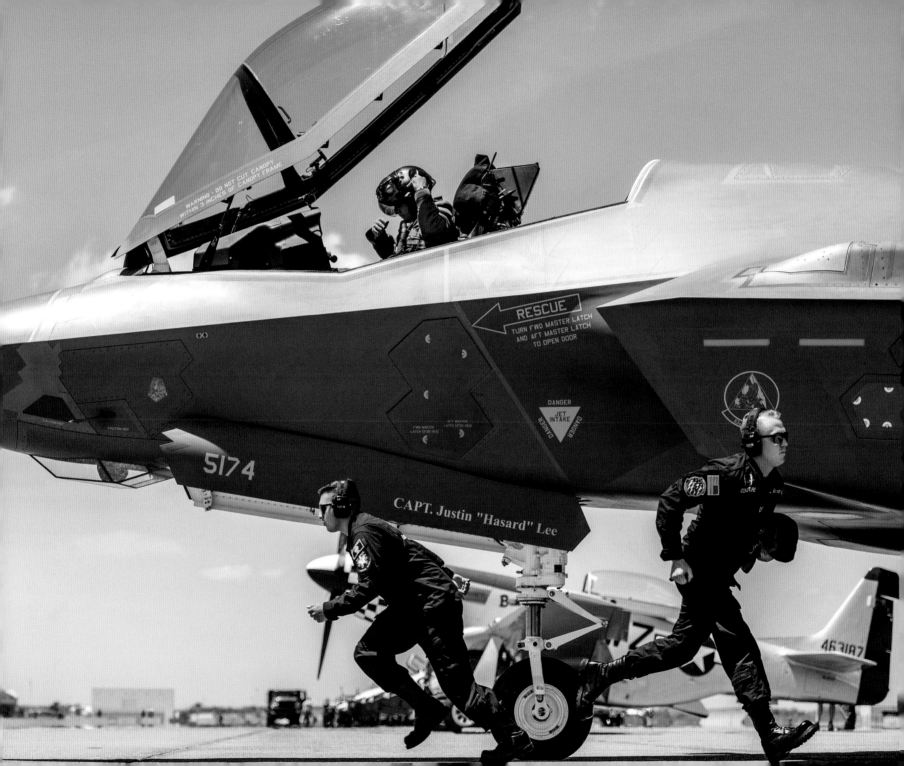

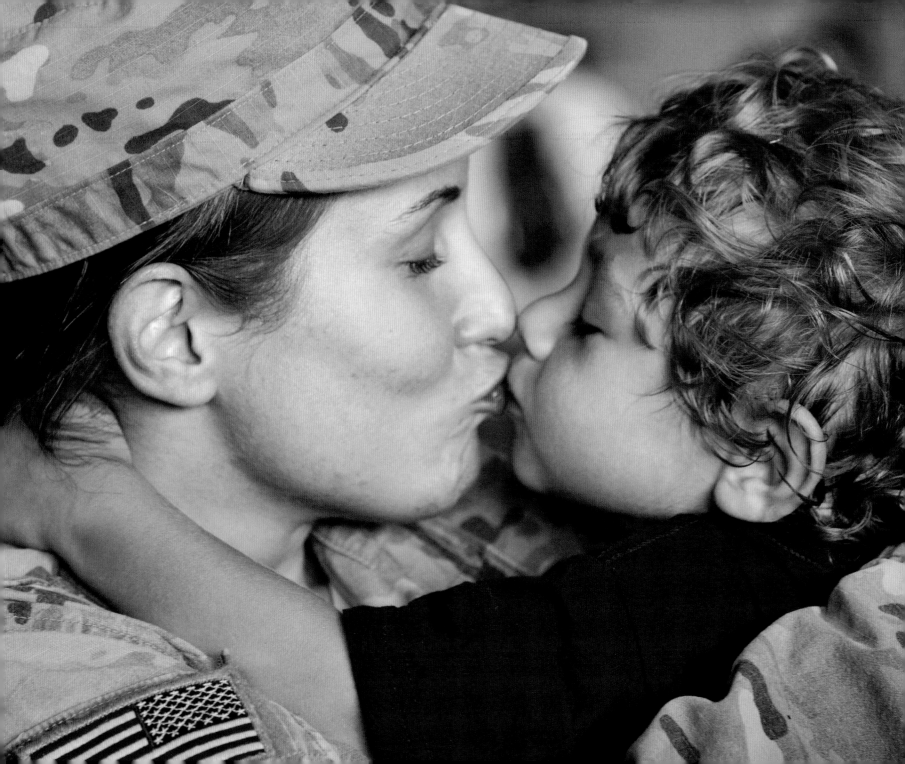

I may be compelled to face danger, *but never fear it.*

—CLARA BARTON

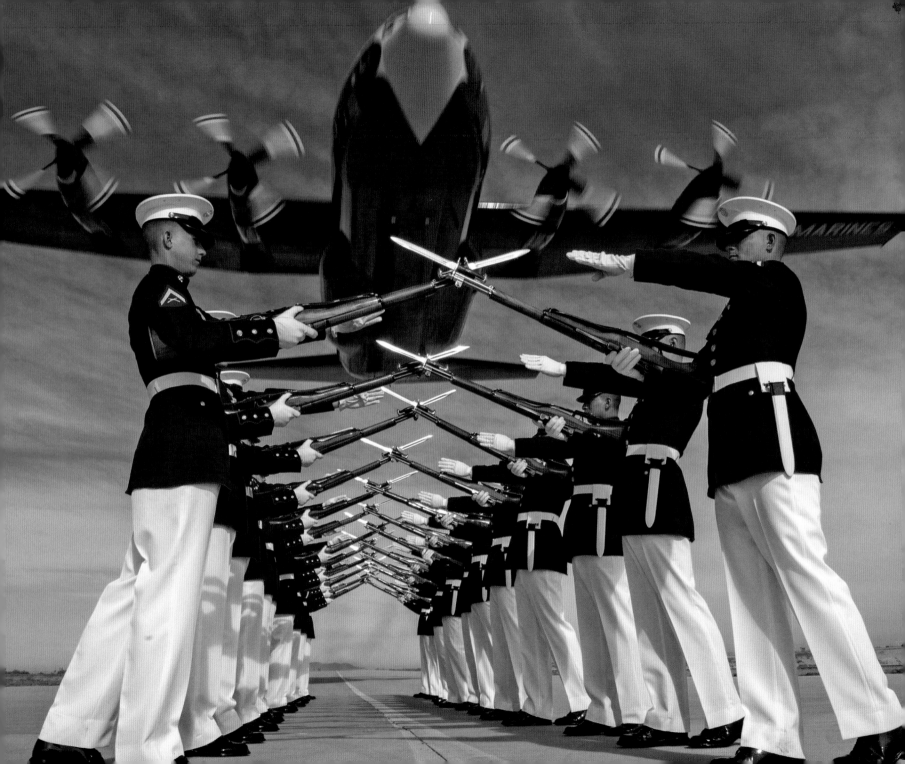

DEDICATED TO DUTY & HONOR

A hero is someone
who has given his or her life
*to something bigger
than oneself.*

—JOSEPH CAMPBELL

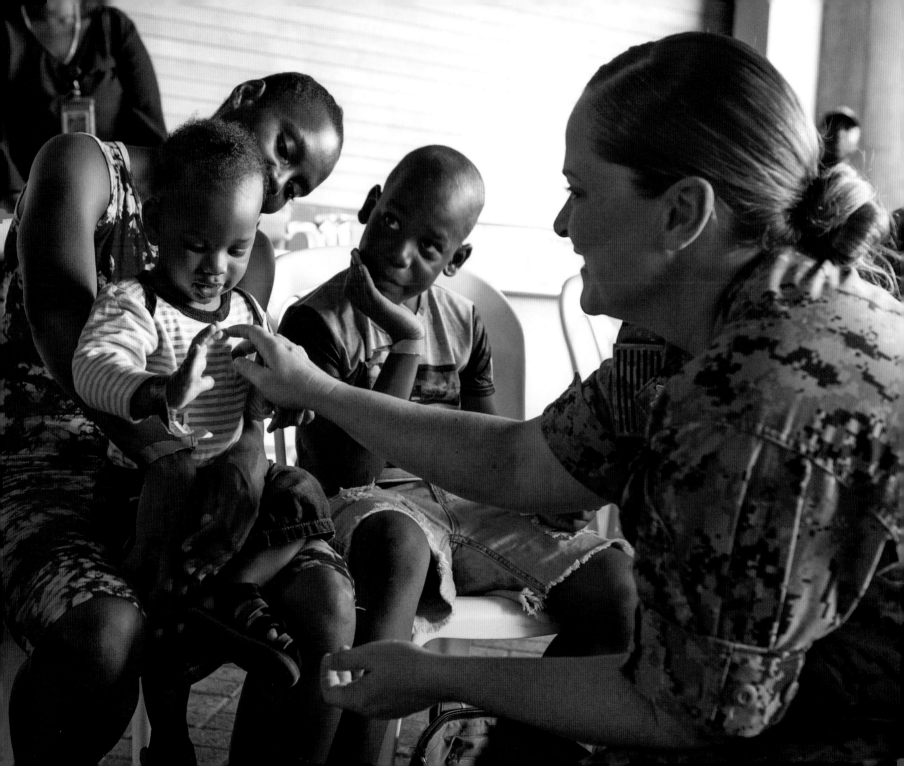

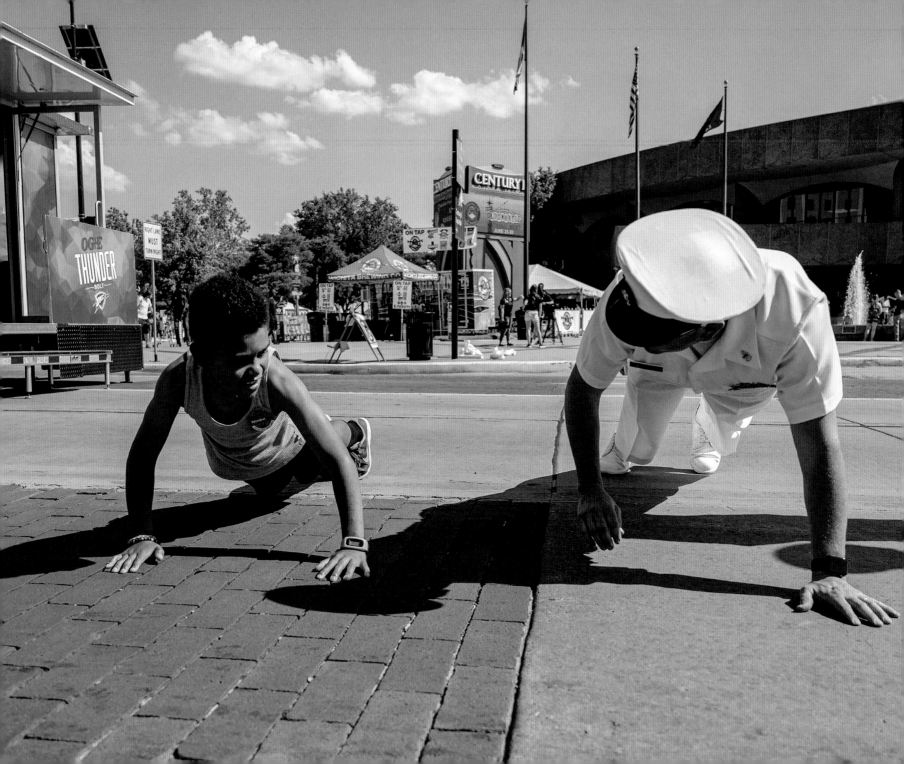

America without her soldiers *would be like God without His angels.*

—CLAUDIA PEMBERTON

In the military,
**YOU LEARN THE
ESSENCE OF PEOPLE.**
You see so many examples of
**SELF-SACRIFICE
AND MORAL COURAGE.**
In the rest of life, you don't get
that many opportunities
to be sure of your friends.

—ADAM DRIVER

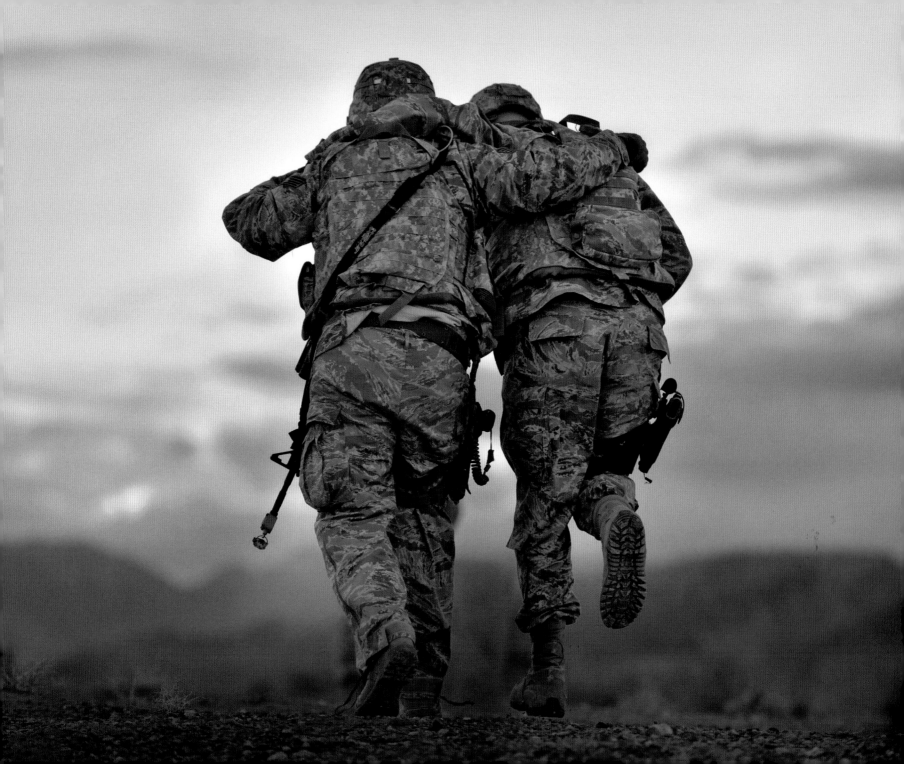

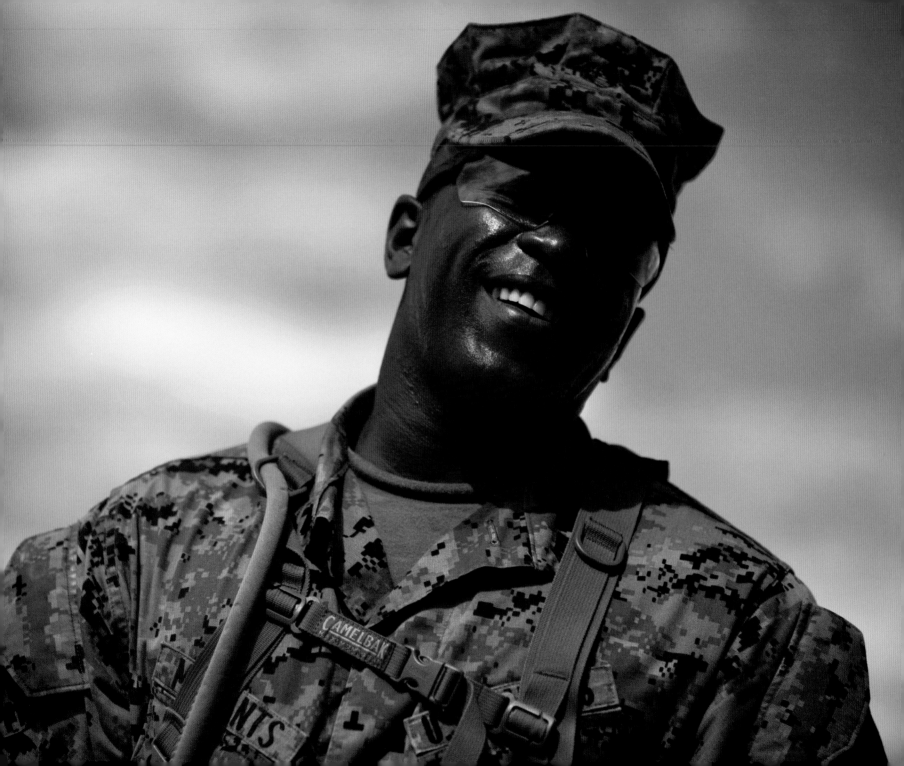

THE SOLDIER'S HEART, THE SOLDIER'S SPIRIT, THE SOLDIER'S SOUL, ARE EVERYTHING.

—GEORGE MARSHALL

Discipline is the soul of an army.

It makes small numbers formidable; procures success to the weak, and esteem to all.

—GEORGE WASHINGTON

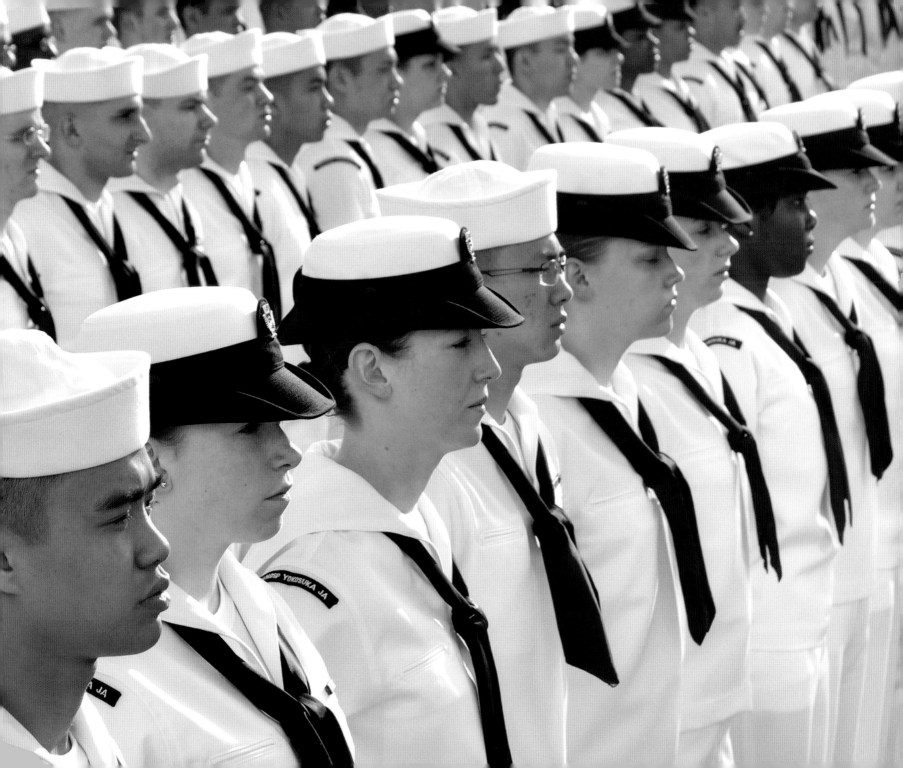

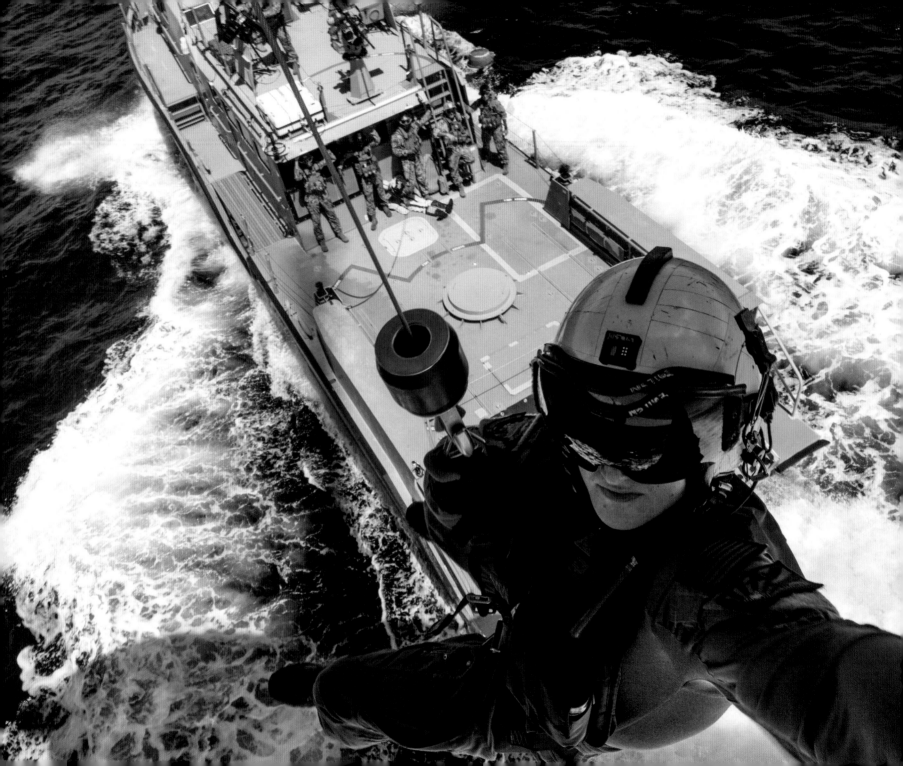

The liberties of our country,

THE FREEDOM OF OUR CIVIL CONSTITUTION,

are worth defending at all hazards.

—SAMUEL ADAMS

Word to the Nation:
GUARD ZEALOUSLY YOUR RIGHT TO SERVE IN THE ARMED FORCES,

for without them, there will be no other rights to guard.

—JOHN F. KENNEDY

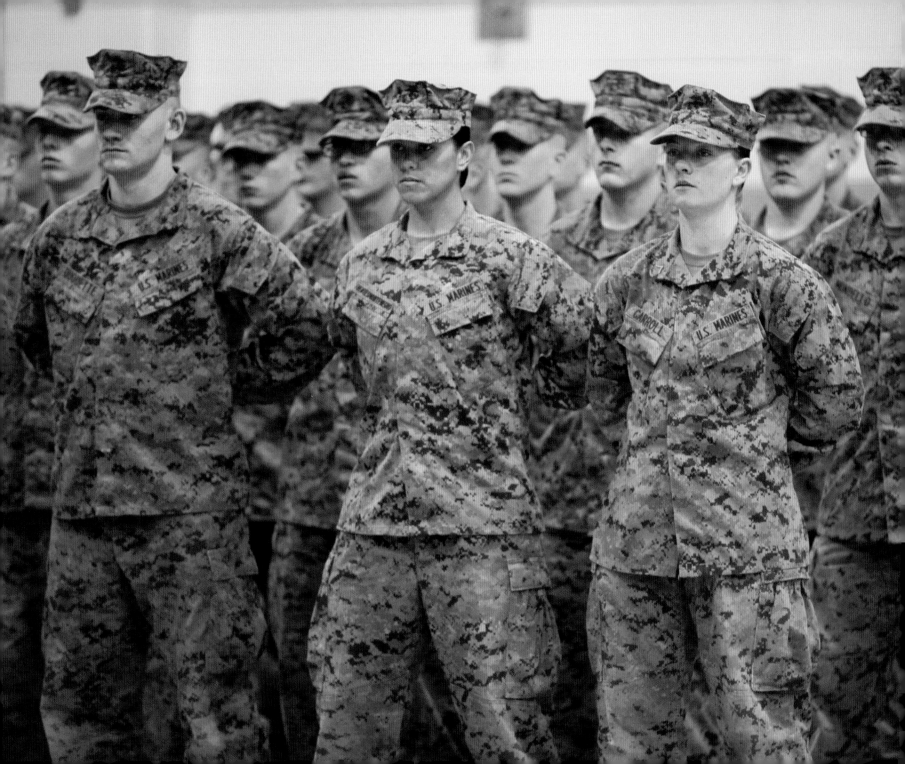

EVERY GOOD CITIZEN
makes his country's honor his own, AND CHERISHES IT NOT ONLY AS PRECIOUS *but as sacred.*

—ANDREW JACKSON

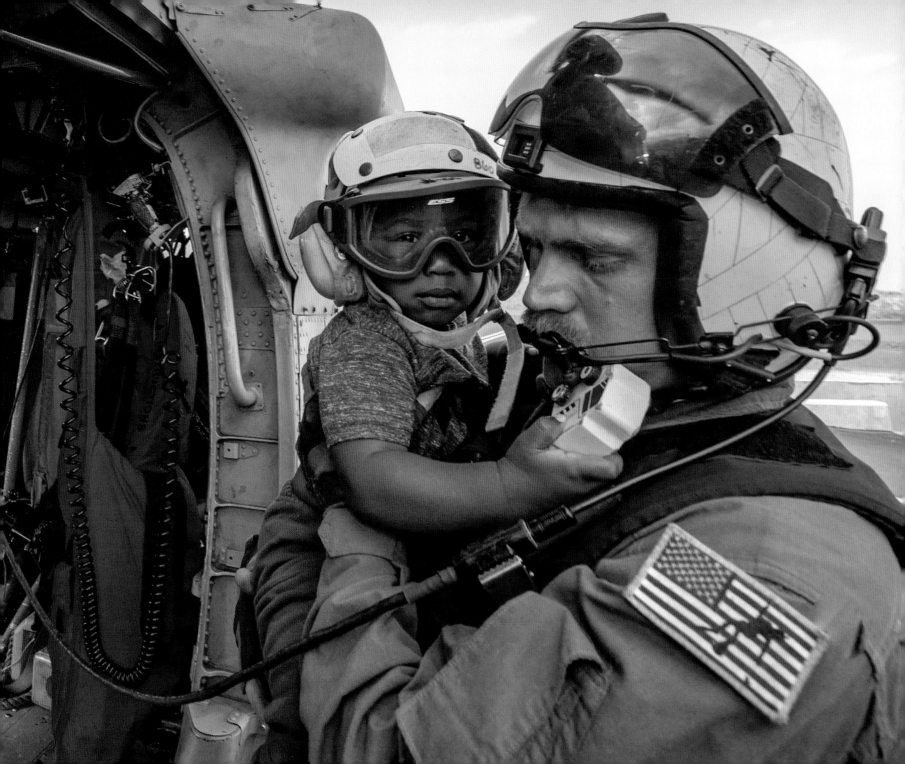

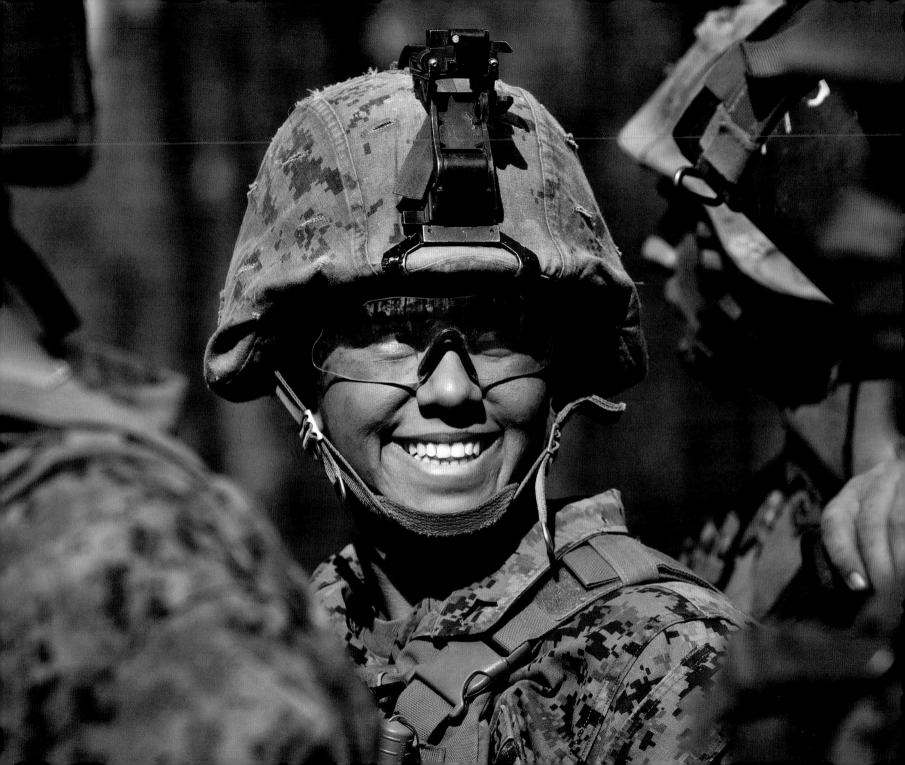

The soldier is the army.
**NO ARMY IS BETTER
THAN ITS SOLDIERS.**

—GEORGE S. PATTON JR.

IF A MAN HASN'T DISCOVERED

something that he will die for,

HE ISN'T FIT TO LIVE.

—MARTIN LUTHER KING JR.

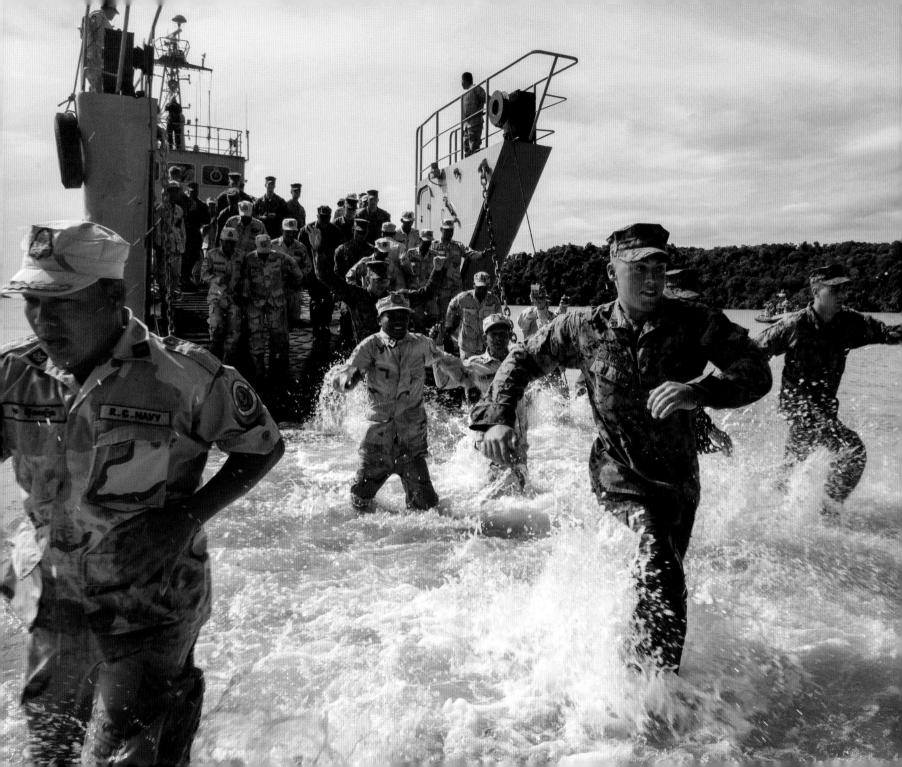

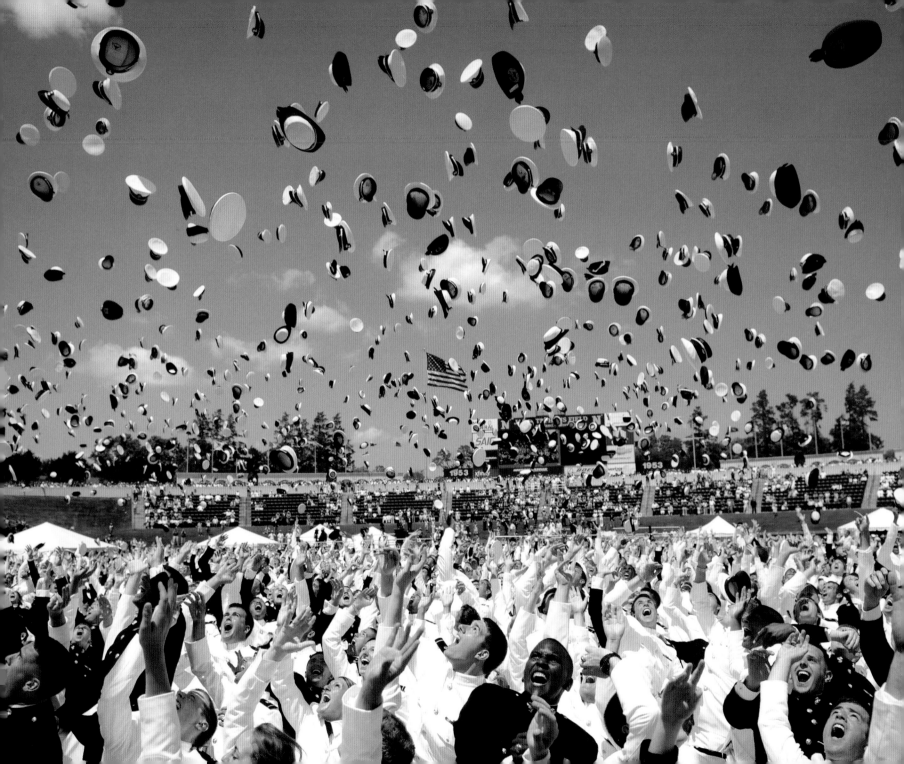

Freedom has its life
IN THE HEARTS,
THE ACTIONS,
the spirit of men.

—DWIGHT D. EISENHOWER

The probability that
we may fail in the struggle
ought not to deter us
from the support of a cause
we believe to be just.

—ABRAHAM LINCOLN

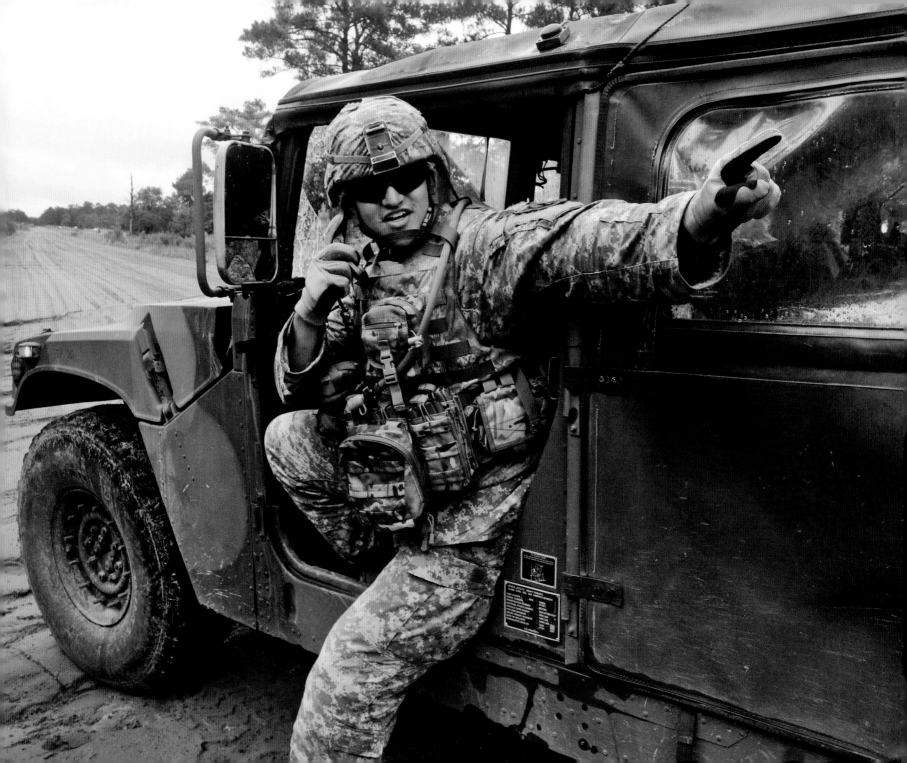

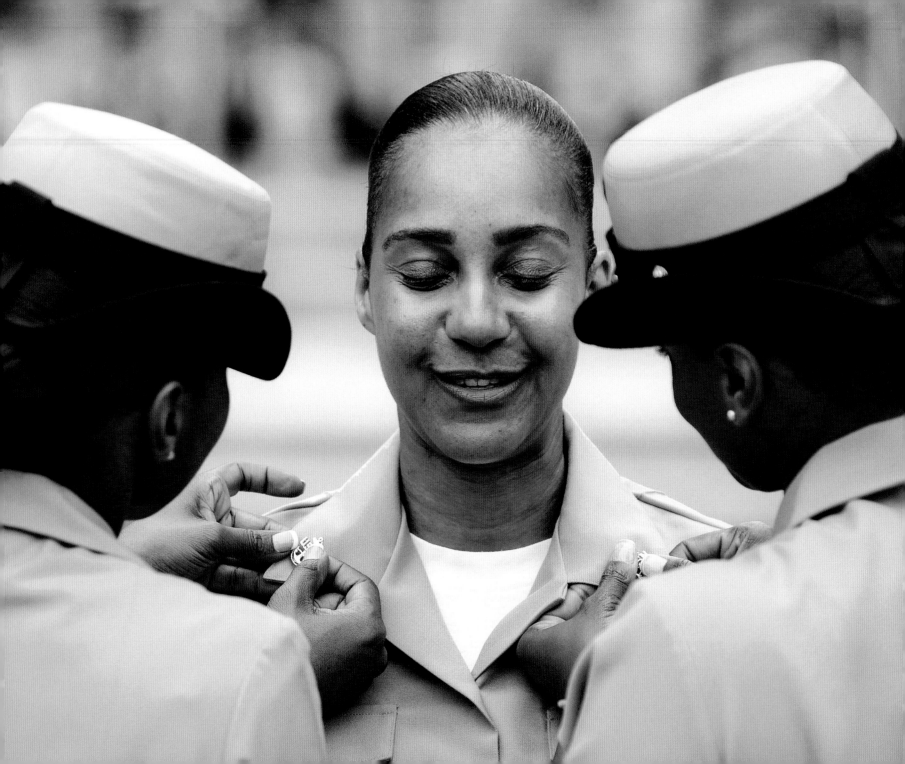

SOLDIERS WATCH WHAT THEIR LEADERS DO. YOU CAN GIVE THEM CLASSES AND LECTURE THEM FOREVER, BUT IT IS YOUR PERSONAL EXAMPLE THEY WILL FOLLOW.

—COLIN POWELL

ONLY OUR
individual faith in freedom
CAN KEEP US FREE.

—DWIGHT D. EISENHOWER

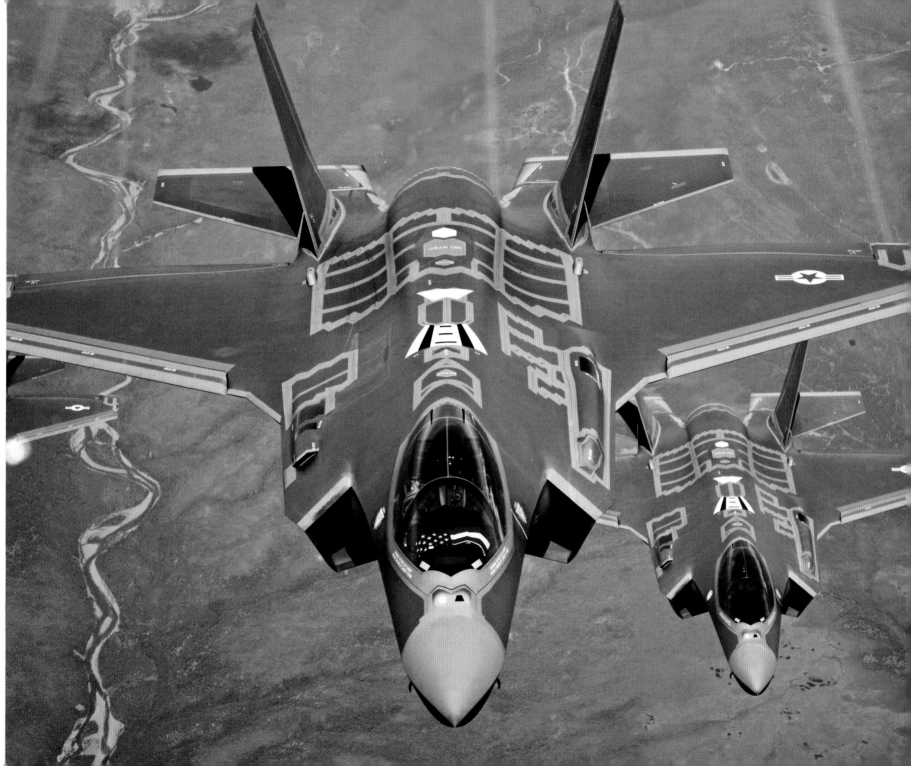

We're blessed with the opportunity **TO STAND FOR SOMETHING—** for liberty and freedom and fairness. **AND THESE ARE THINGS WORTH FIGHTING FOR,** worth devoting our lives to.

—RONALD REAGAN

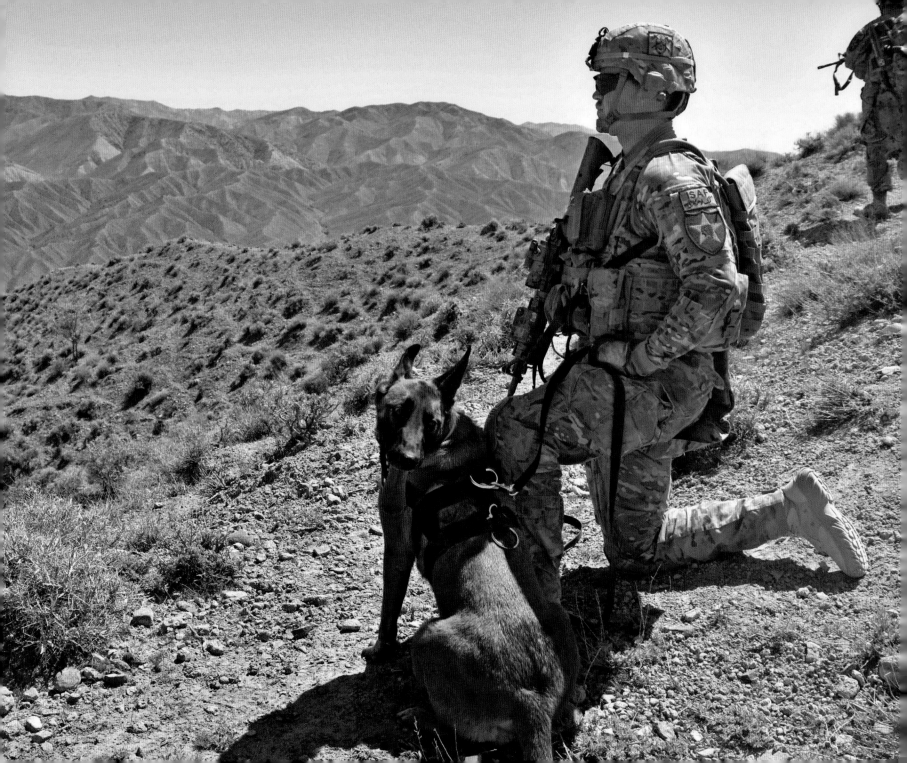

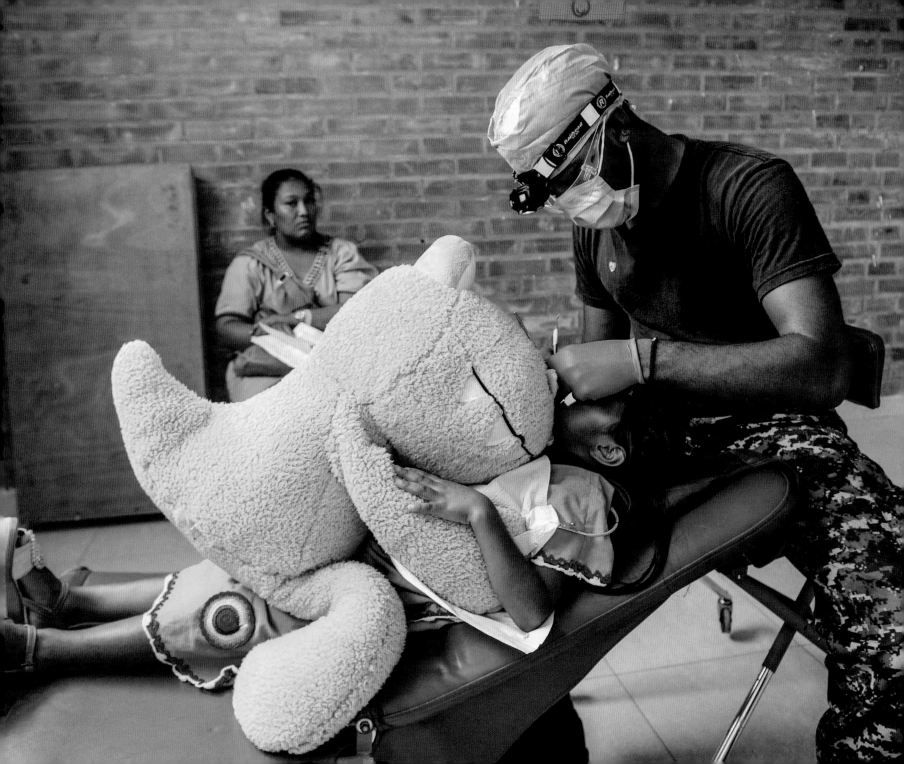

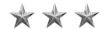

**BETTER THAN
HONOR AND GLORY, AND
HISTORY'S IRON PEN,
WAS THE THOUGHT
OF DUTY DONE
AND THE LOVE OF
HIS FELLOW MEN.**

—RICHARD WATSON GILDER

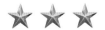

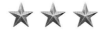

The world must be made **SAFE FOR DEMOCRACY.**

—WOODROW WILSON

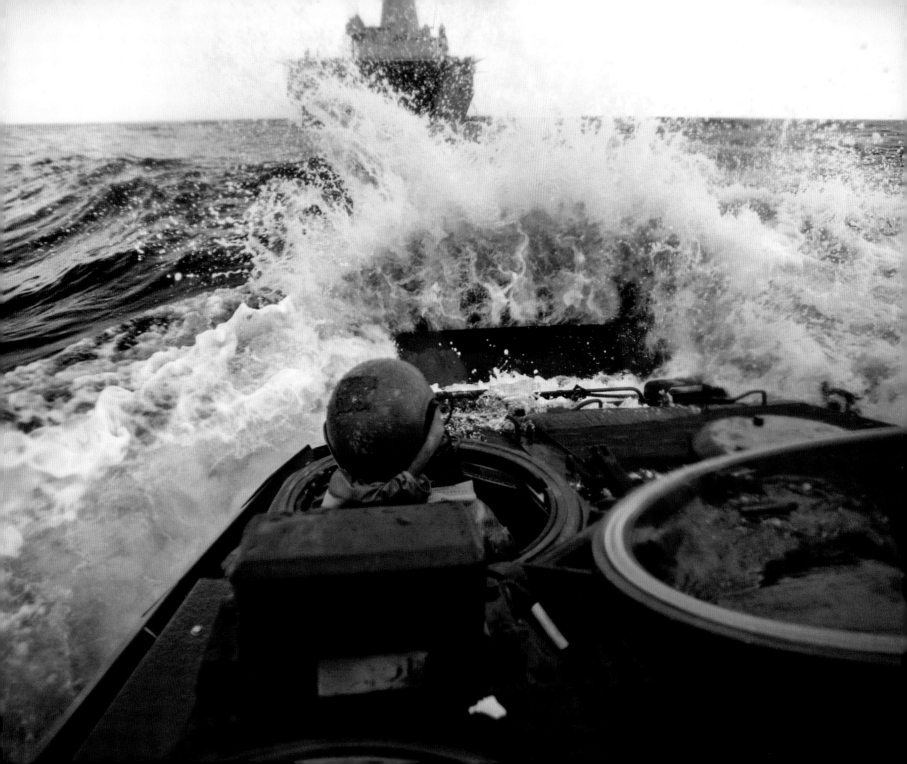

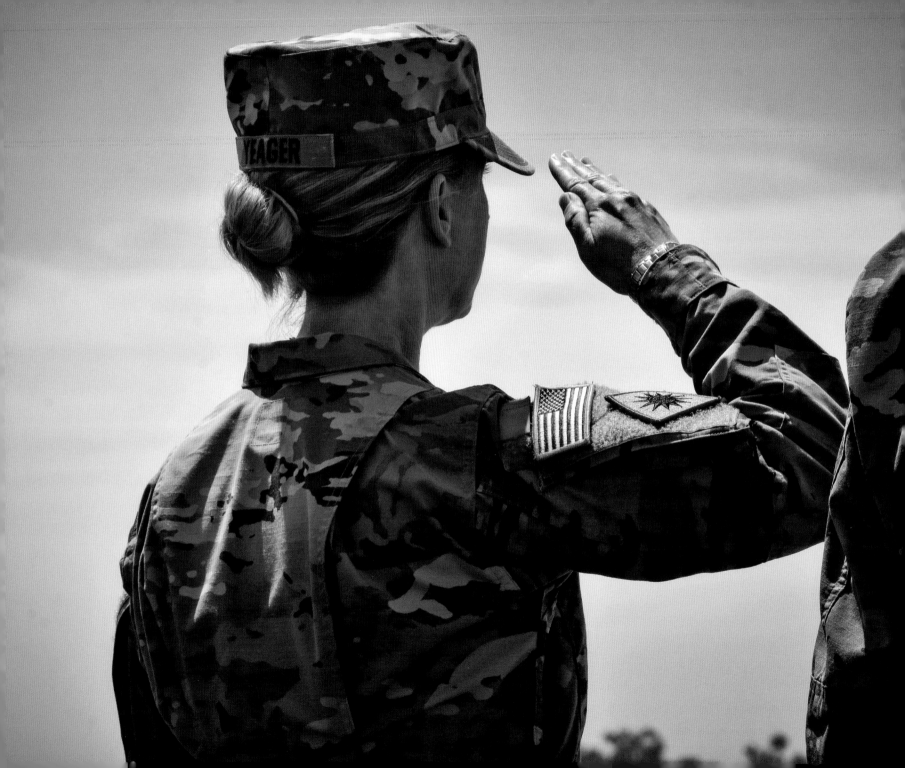

★ COUNTRY OVER SELF ★

Nothing in life
is more liberating
than to fight for a cause
larger than yourself.

—JOHN McCAIN

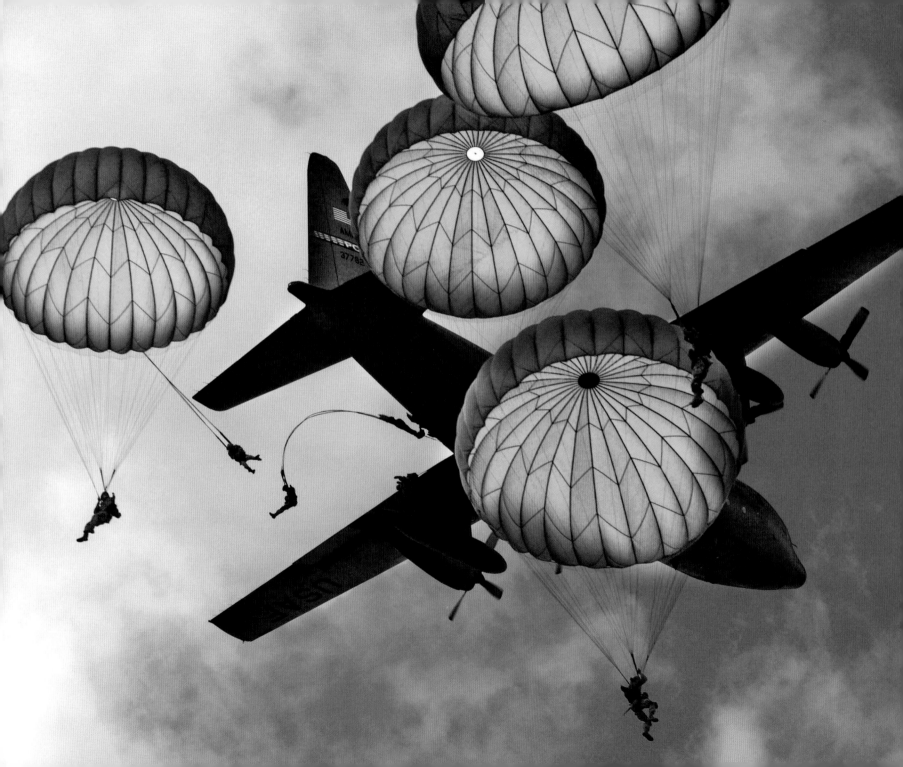

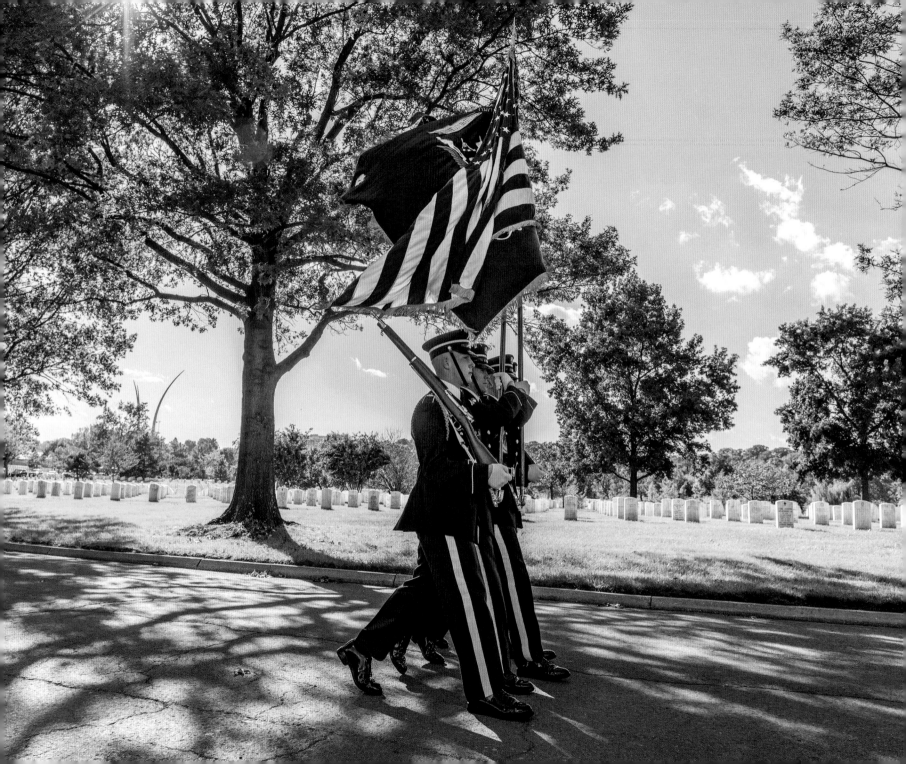

This nation will remain
the land of the free
only so long as it is
the home of the brave.

—ELMER DAVIS

America's fighting men and women

SACRIFICE MUCH TO ENSURE

that our great nation stays free.

—ALLEN BOYD

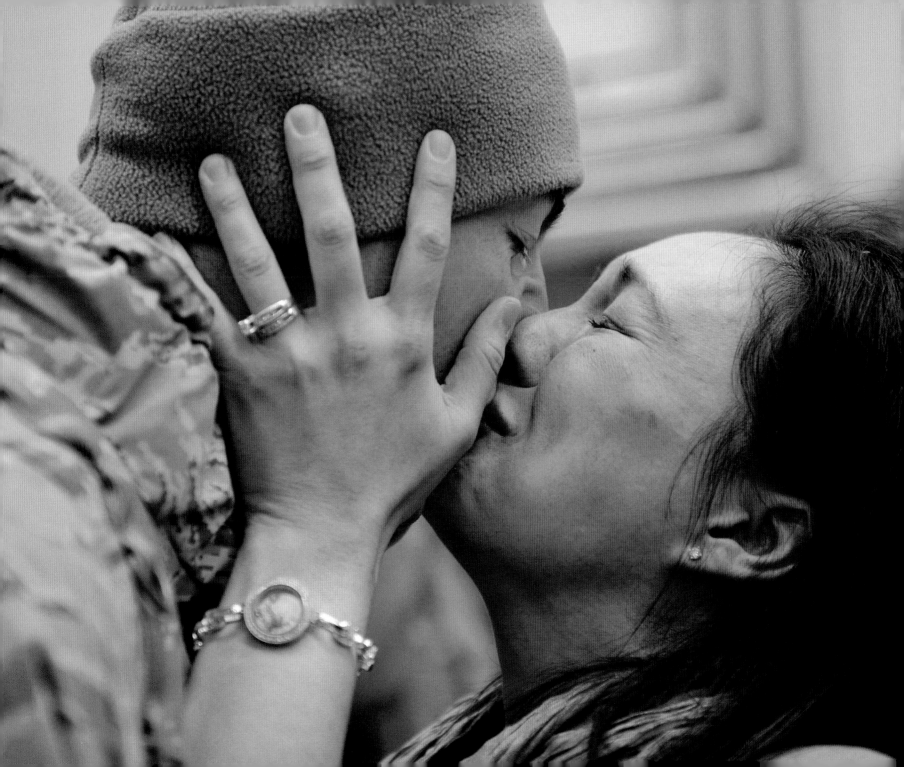

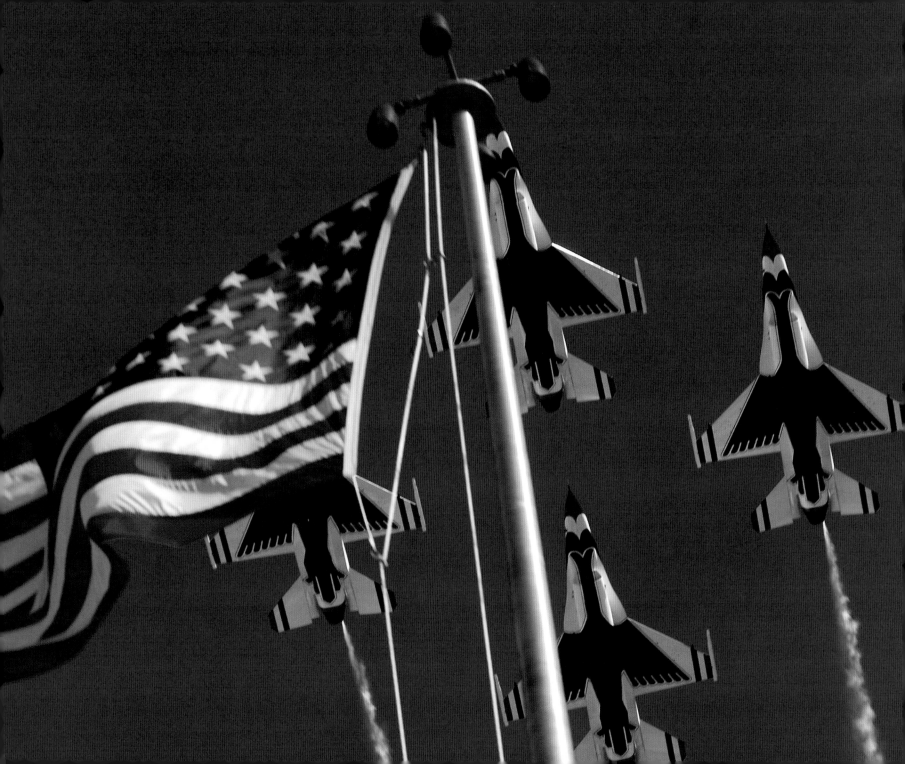

We will stand by the right,
we will stand by the true,

**we will live,
we will die
for the red, white,
and blue.**

—UNKNOWN

The soldier,
above all other people,
prays for peace,
for he must suffer and bear
the deepest wounds
and scars of war.

—DOUGLAS MacARTHUR

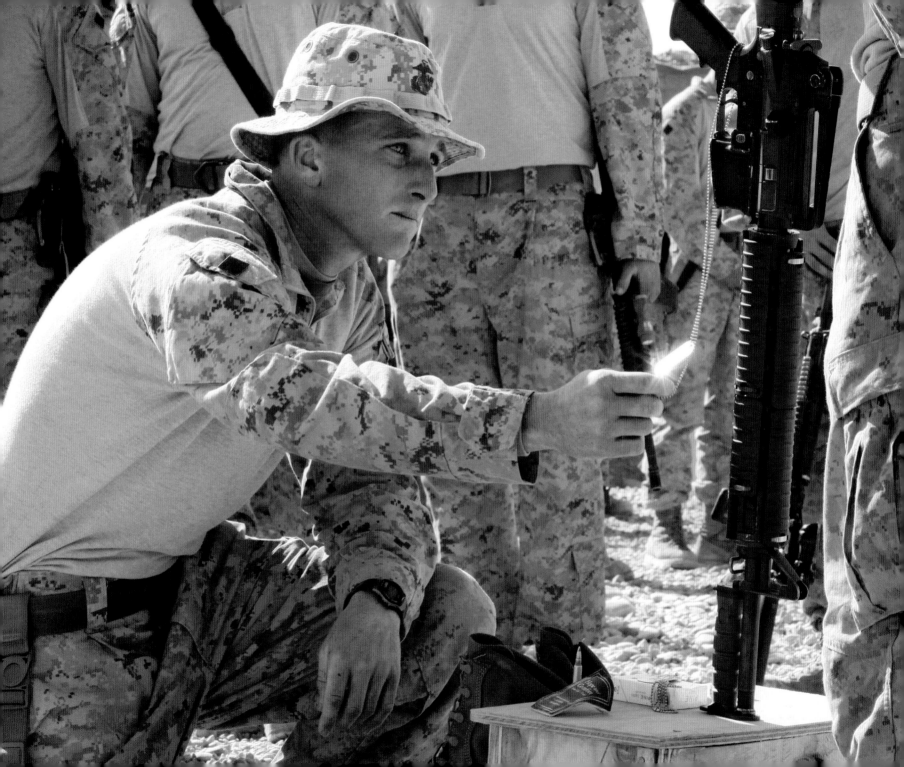

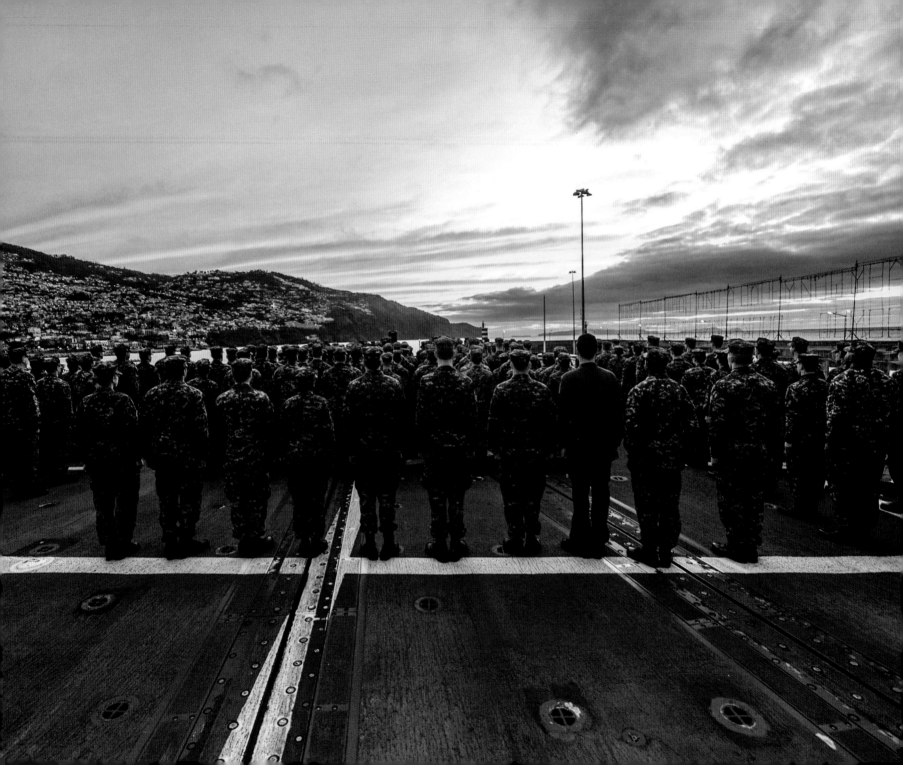

Patriotism consists not in waving the flag, but in striving that **OUR COUNTRY SHALL BE RIGHTEOUS AS WELL AS STRONG.**

—JAMES BRYCE

We cannot be
separated in interest
or divided in purpose.
*We stand together
until the end.*

—WOODROW WILSON

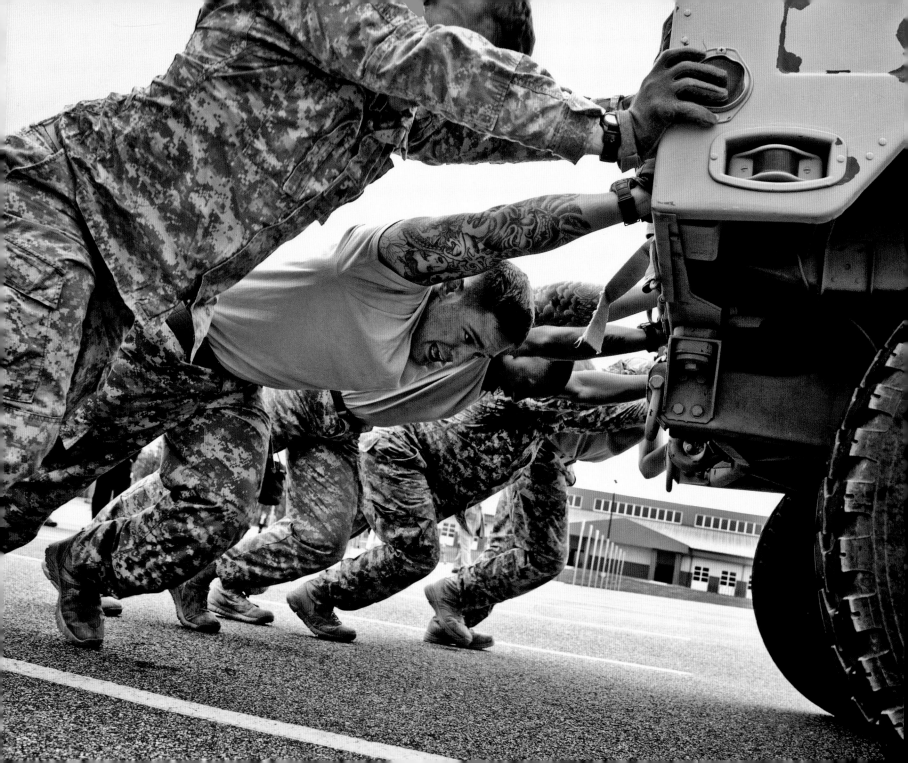

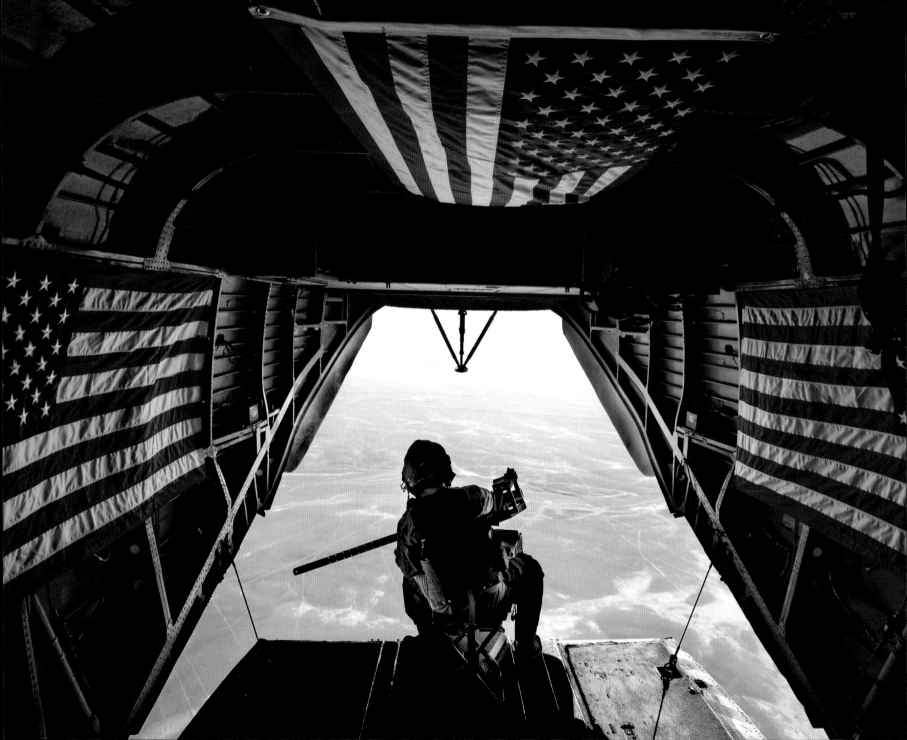

One flag, one land,
one heart, one hand,
one nation evermore!

—OLIVER WENDELL HOLMES

THE COST OF FREEDOM IS ALWAYS HIGH, BUT AMERICANS HAVE ALWAYS PAID IT.

—JOHN F. KENNEDY

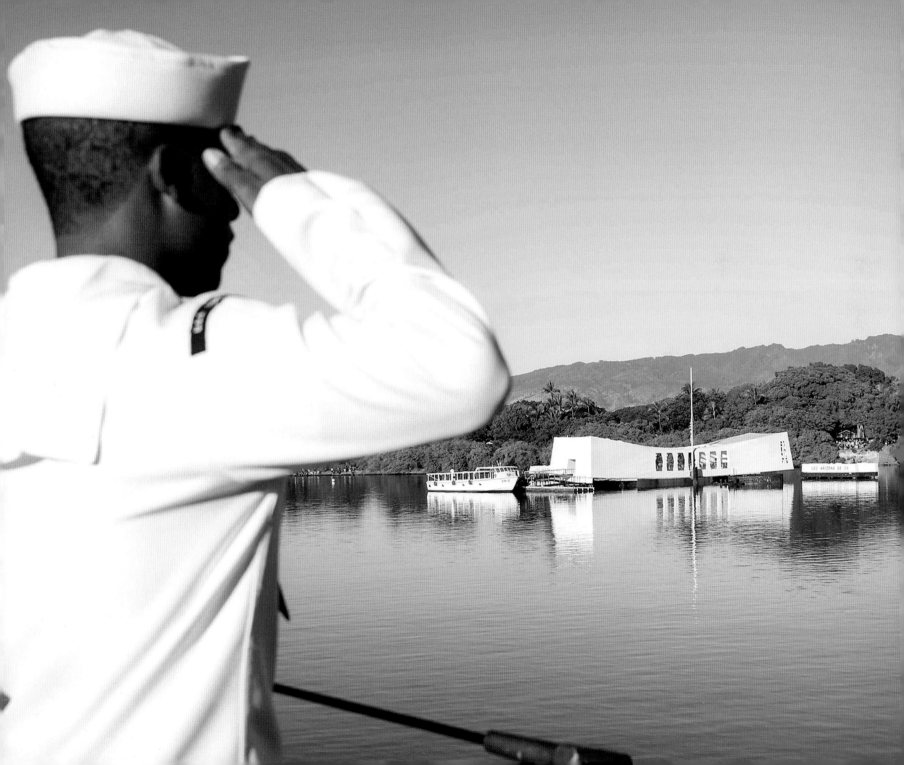

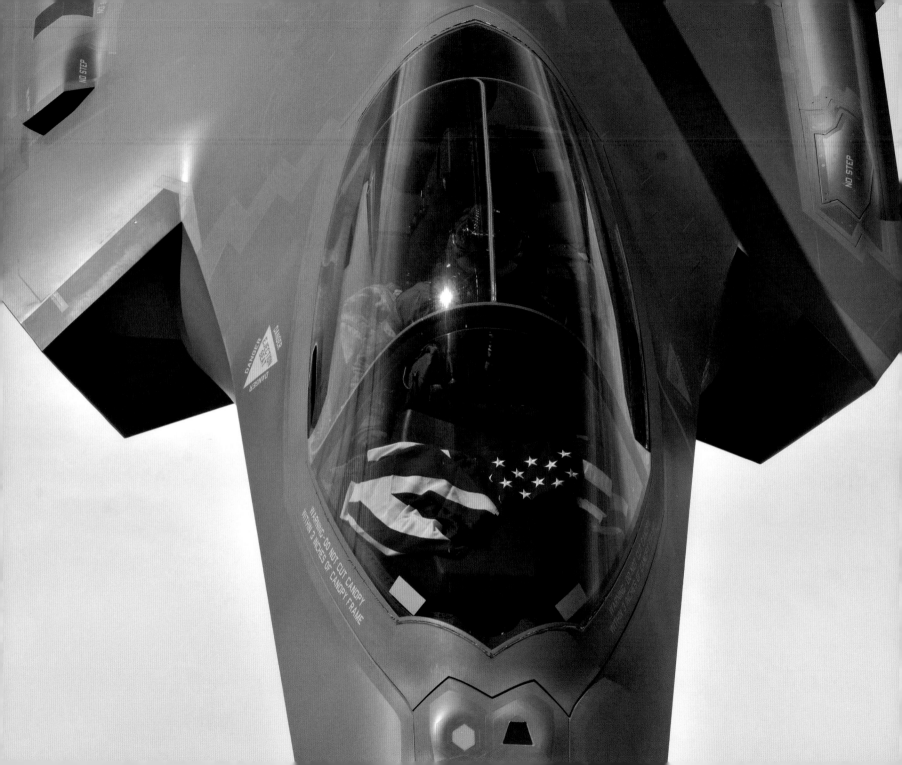

Where liberty dwells,
there is my country.

—BENJAMIN FRANKLIN

A man's country
is not a certain area of land,
of mountains, rivers, and woods,
**but it is a principle;
and patriotism is loyalty
to that principle.**

—GEORGE WILLIAM CURTIS

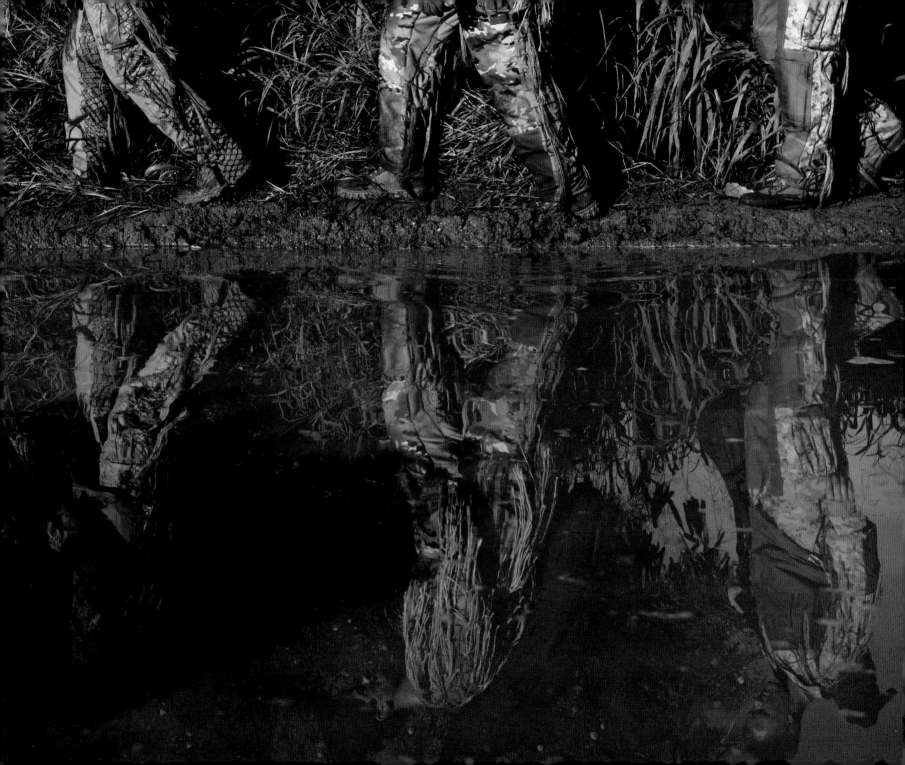

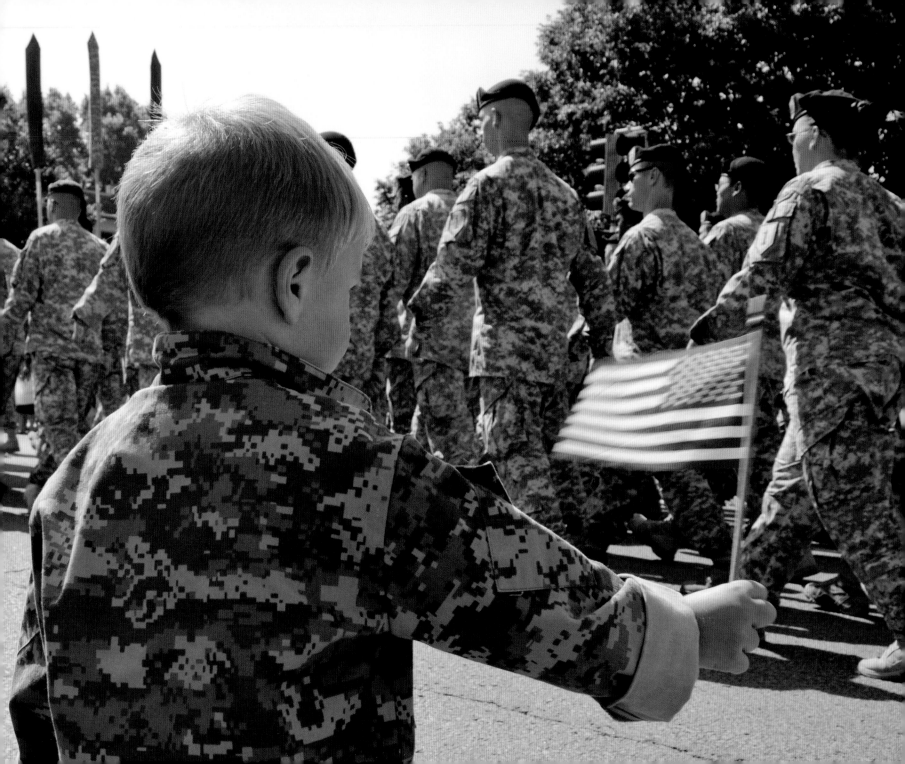

Freedom is never more than
one generation away from extinction.
**It must be fought for,
protected, and handed on**
for [our children] to do the same.

—RONALD REAGAN

We will be soldiers,
so our sons may be farmers,
so their sons may be artists.

—THOMAS JEFFERSON

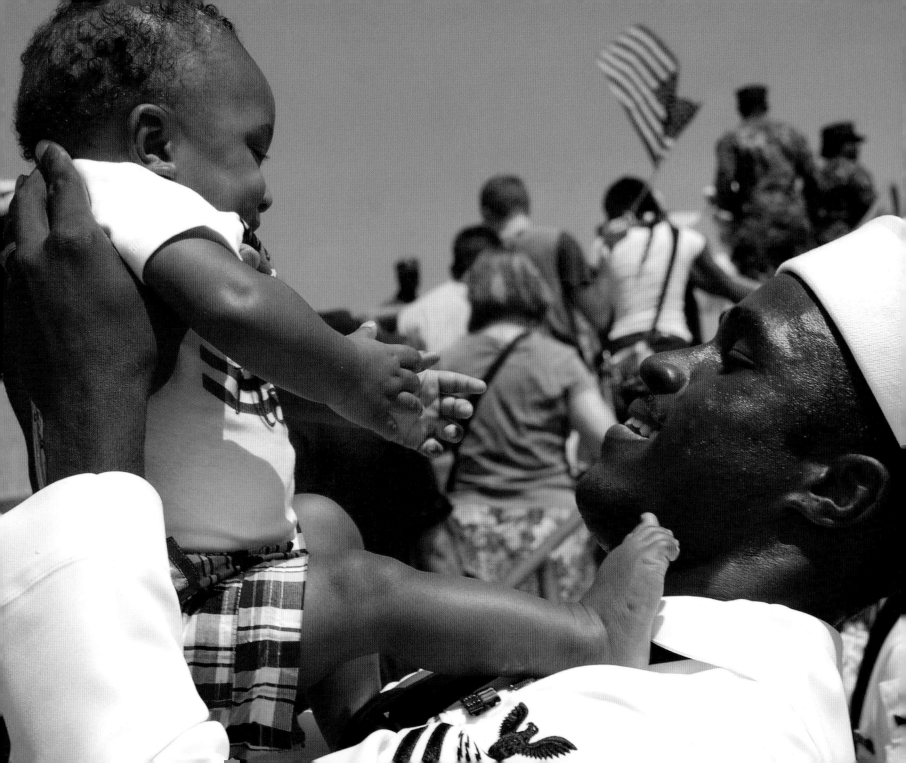

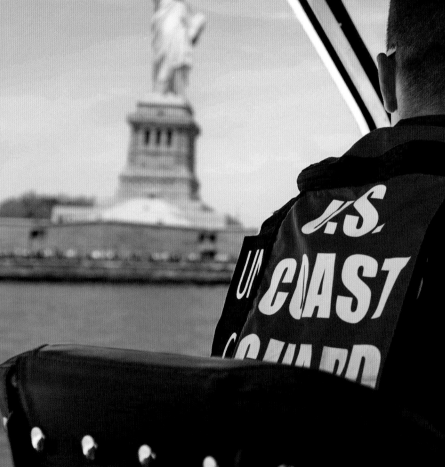

THE NATION WHICH
forgets its defenders
WILL BE ITSELF FORGOTTEN.

—CALVIN COOLIDGE

HE LOVES HIS COUNTRY BEST

WHO STRIVES TO MAKE IT BEST.

—ROBERT G. INGERSOLL

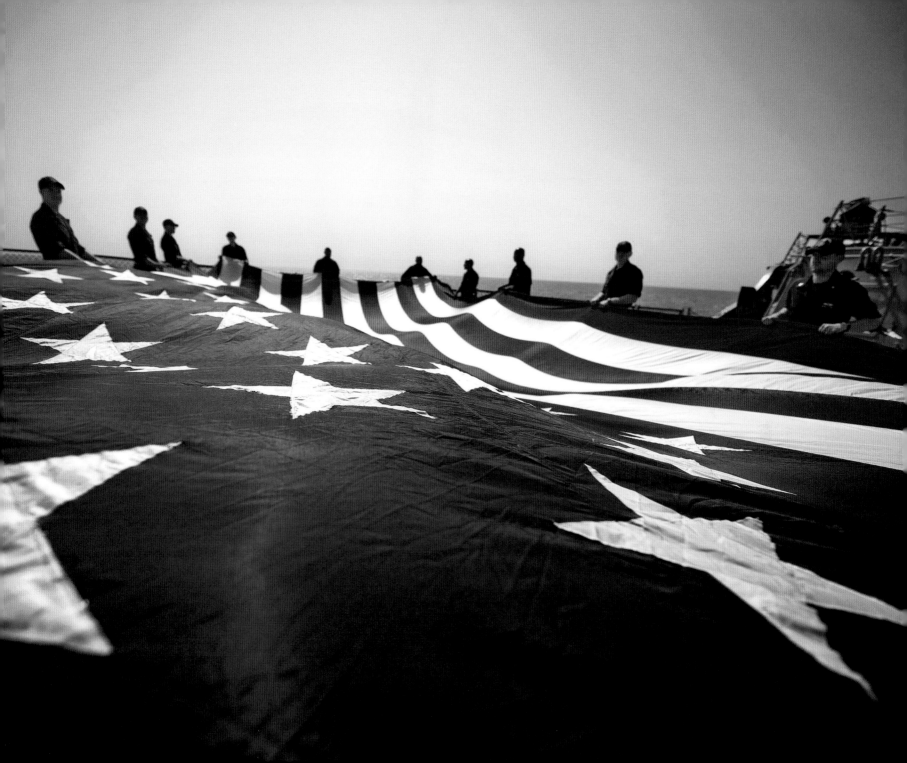

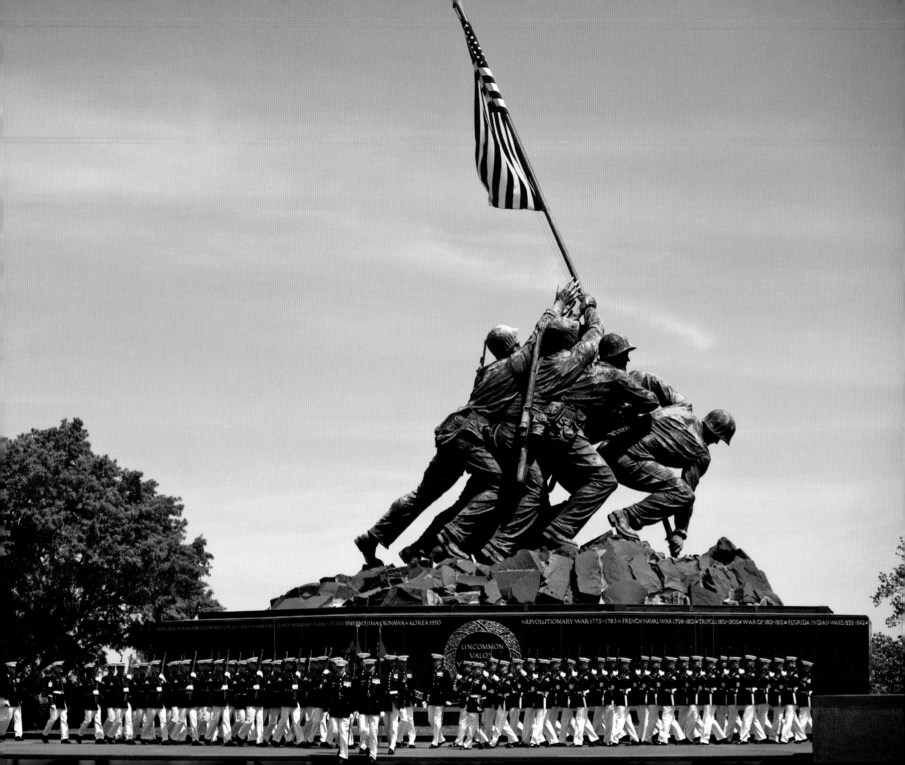

I only regret that
I have but one life to lose
for my country.

—NATHAN HALE

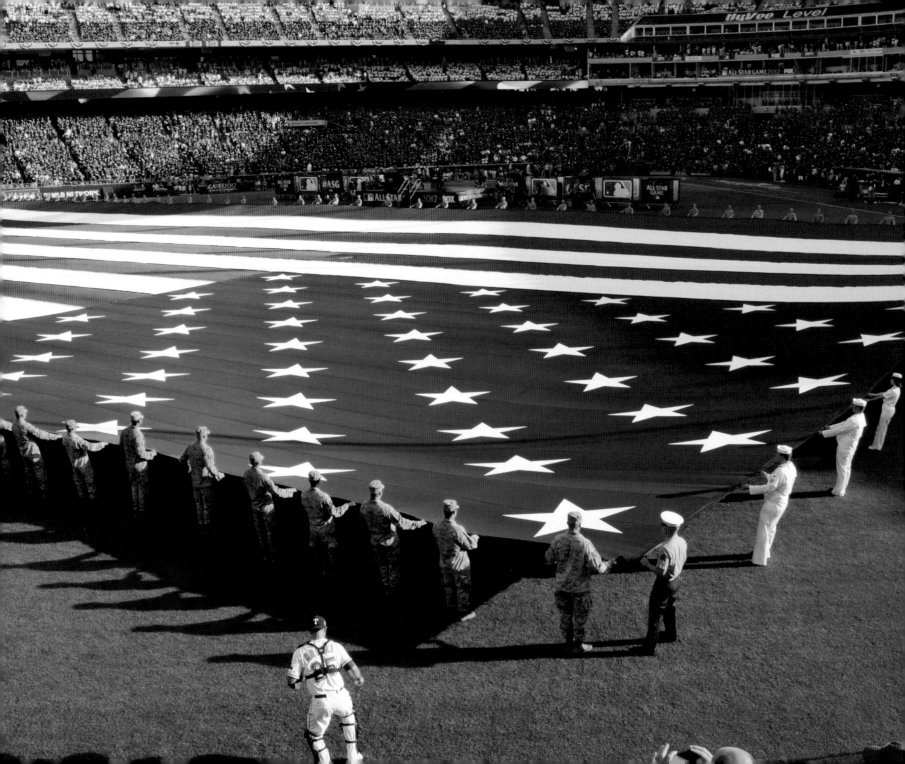

★ TRUE GLORY ★

There are men and women *who make the world better* just by being the kind of people they are.

—JAMES GARFIELD

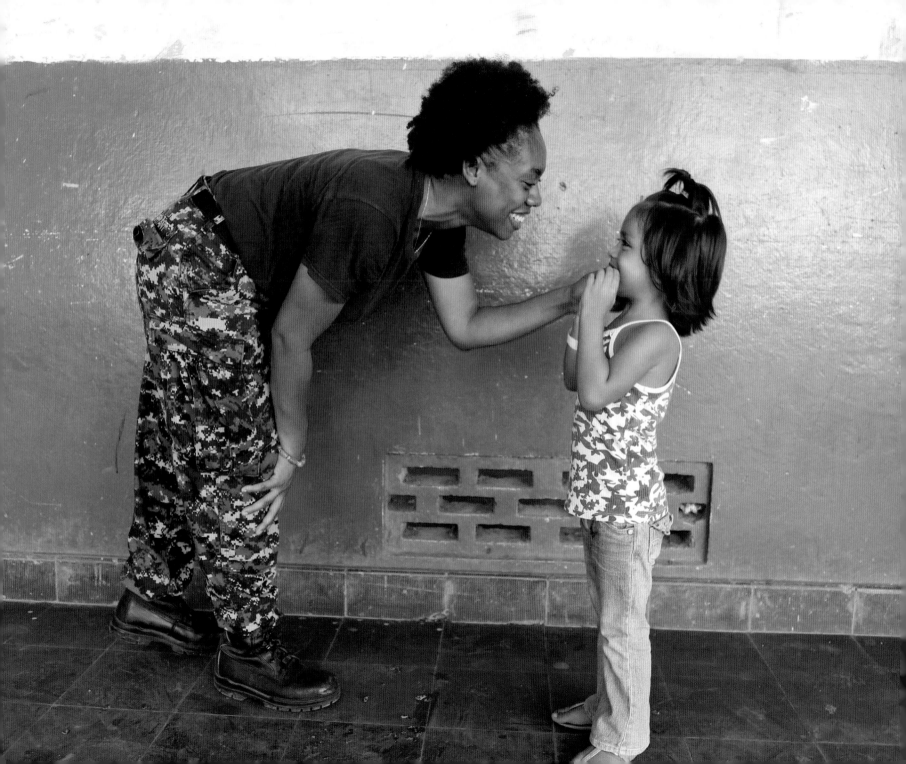

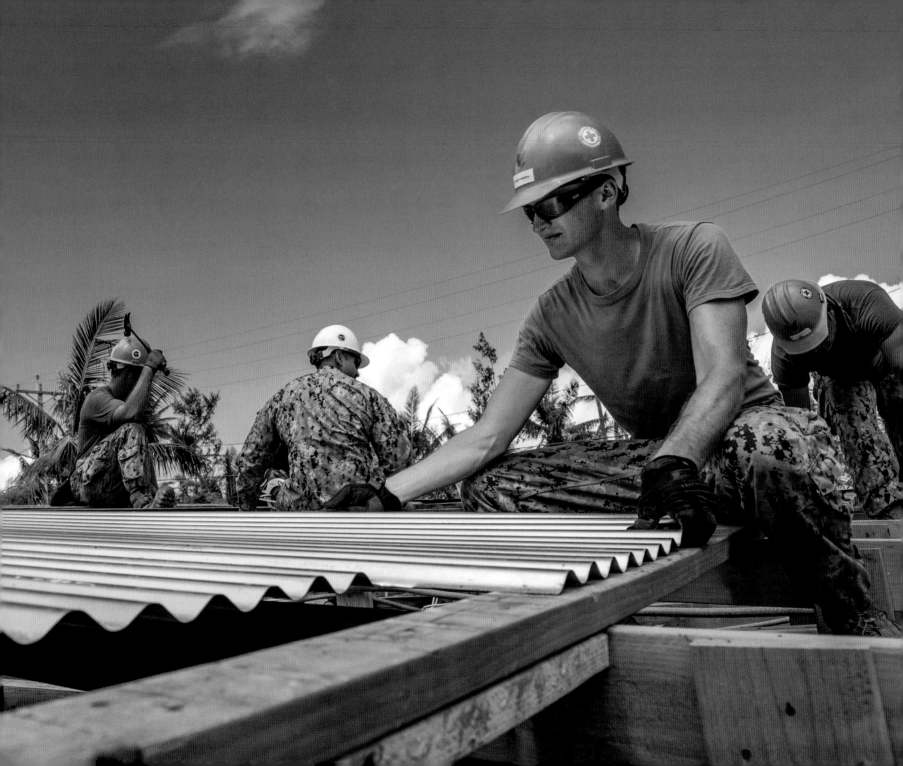

It is amazing what you can accomplish

if you do not care
who gets the credit.

—HARRY TRUMAN

WE'RE ALL IN THIS TOGETHER
IF WE'RE IN IT AT ALL.

—JOHNNY CASH

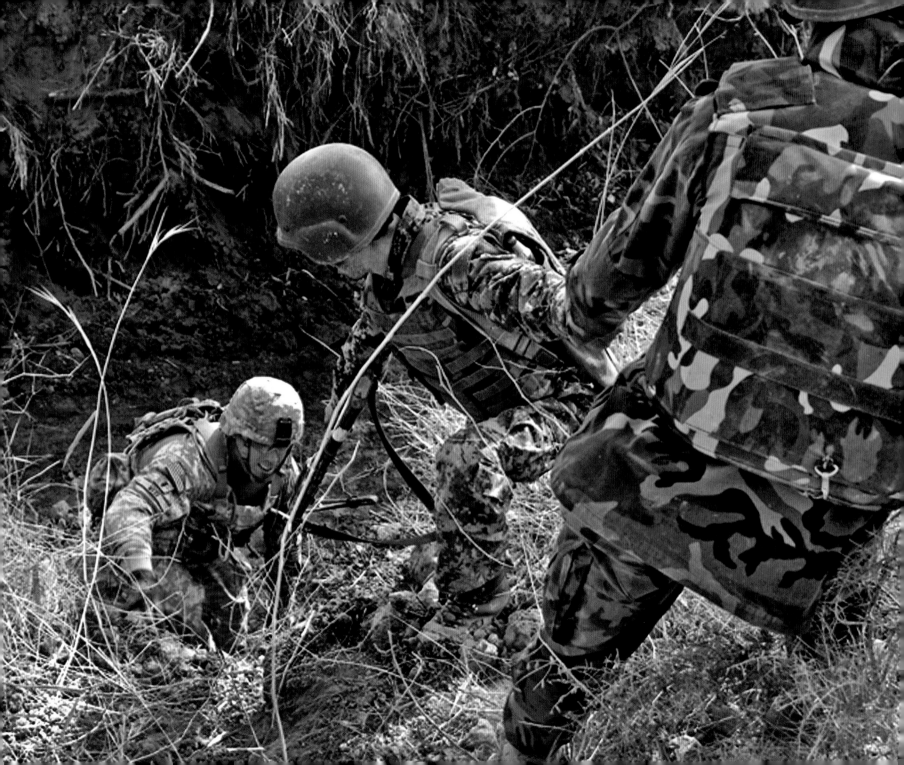

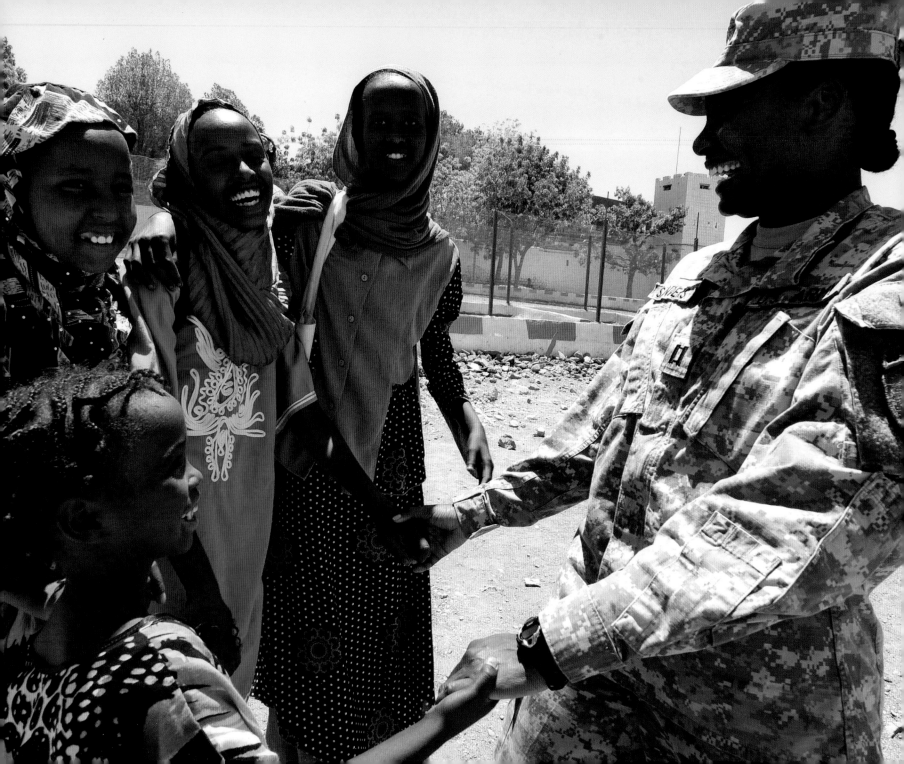

How important it is for us to recognize and *celebrate our heroes and she-roes!*

—MAYA ANGELOU

Strength grows

IN THE MOMENTS YOU THINK YOU CAN'T GO ON,

but you keep going anyway.

—UNKNOWN

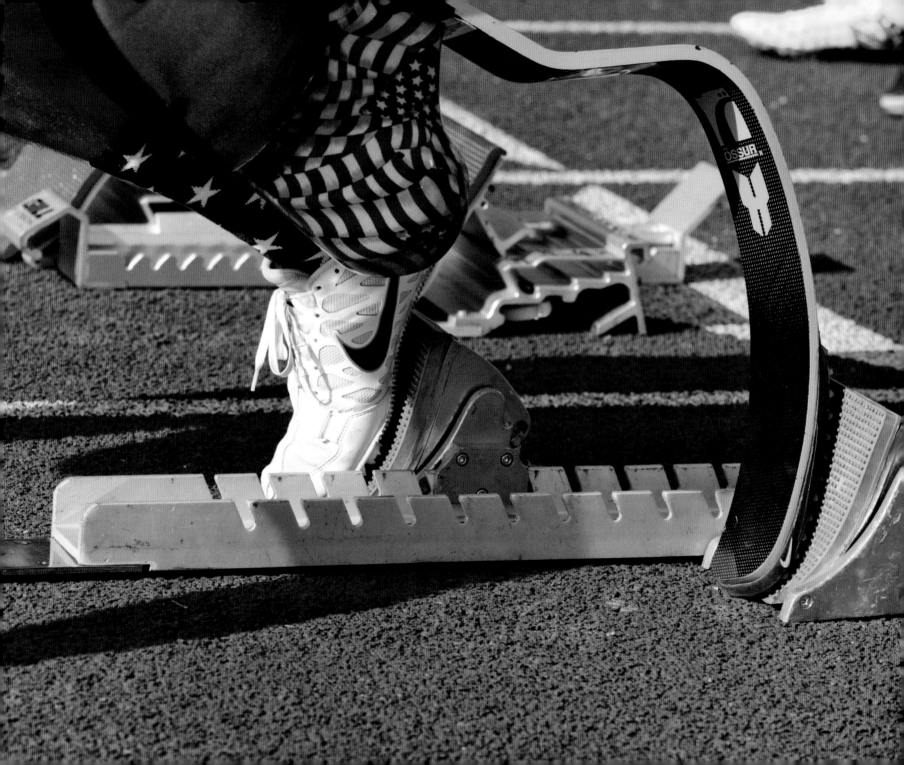

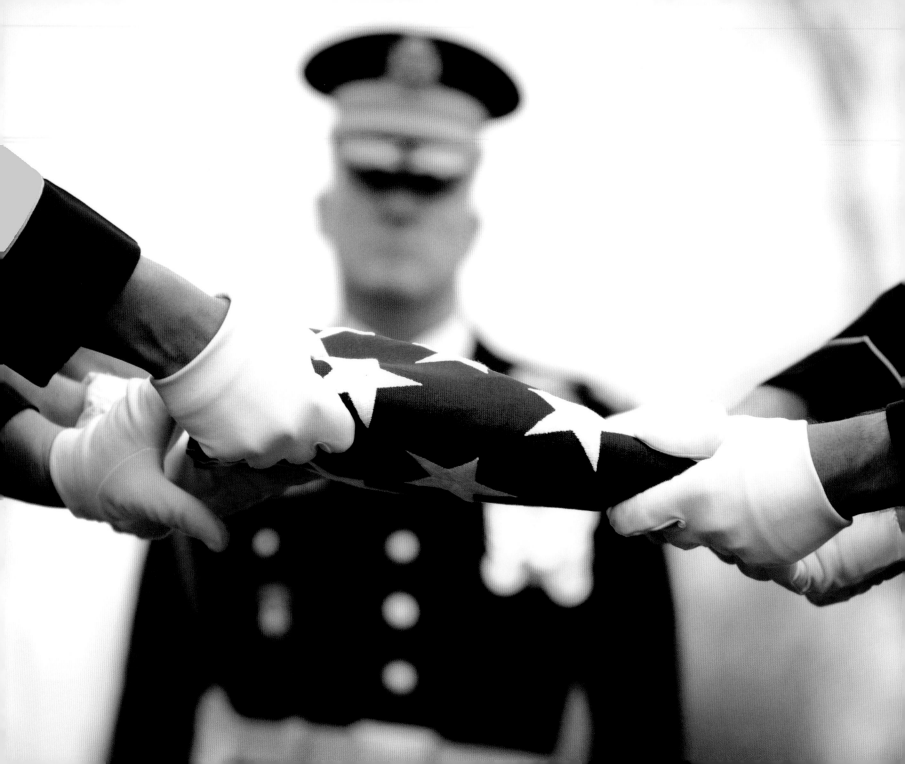

It is foolish and wrong
to mourn the men who died.

RATHER WE SHOULD THANK GOD THAT SUCH MEN LIVED.

—GEORGE S. PATTON JR.

You always know the right thing to do.
The hard part is doing it.

—NORMAN SCHWARZKOPF

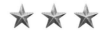

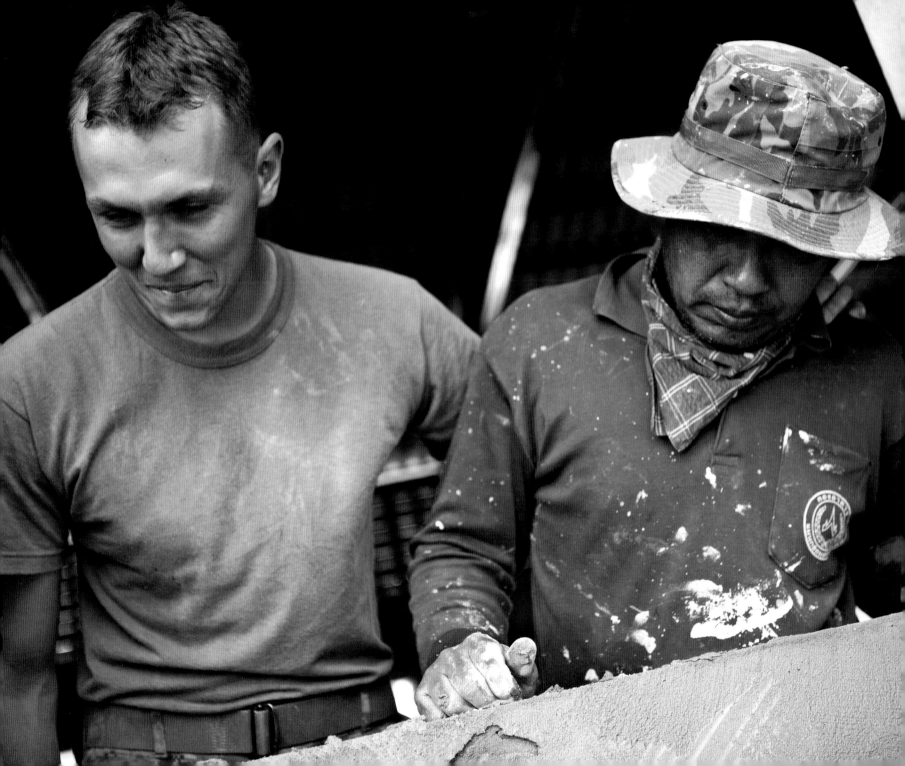

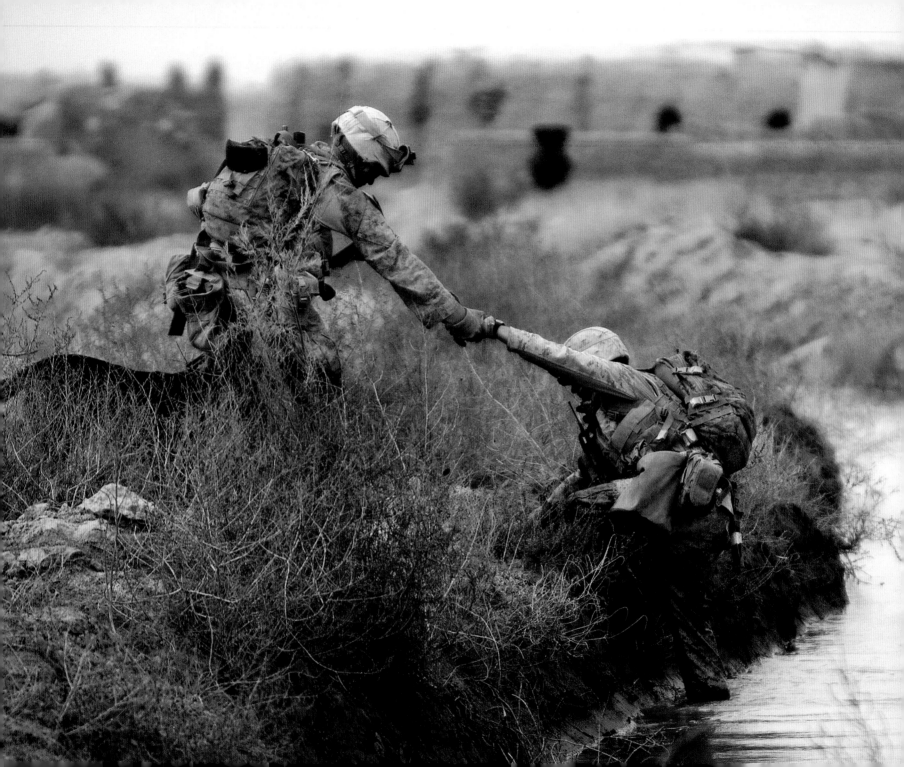

The supreme quality for leadership is

UNQUESTIONABLY INTEGRITY. WITHOUT IT, NO REAL SUCCESS IS POSSIBLE,

no matter whether it is on
a section gang, a football field,
in an army, or in an office.

—DWIGHT D. EISENHOWER

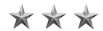

Glory belongs to
**the act of being
constant to something
greater than yourself,**
to a cause, to your principles,
to the people on whom you rely
and who rely on you.

—JOHN McCAIN

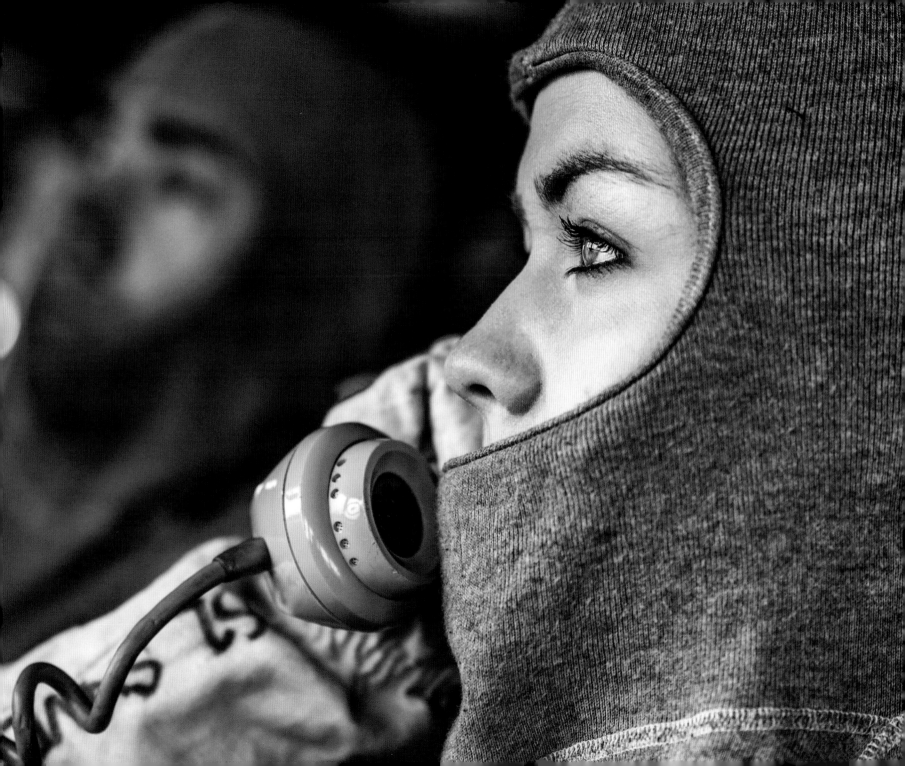

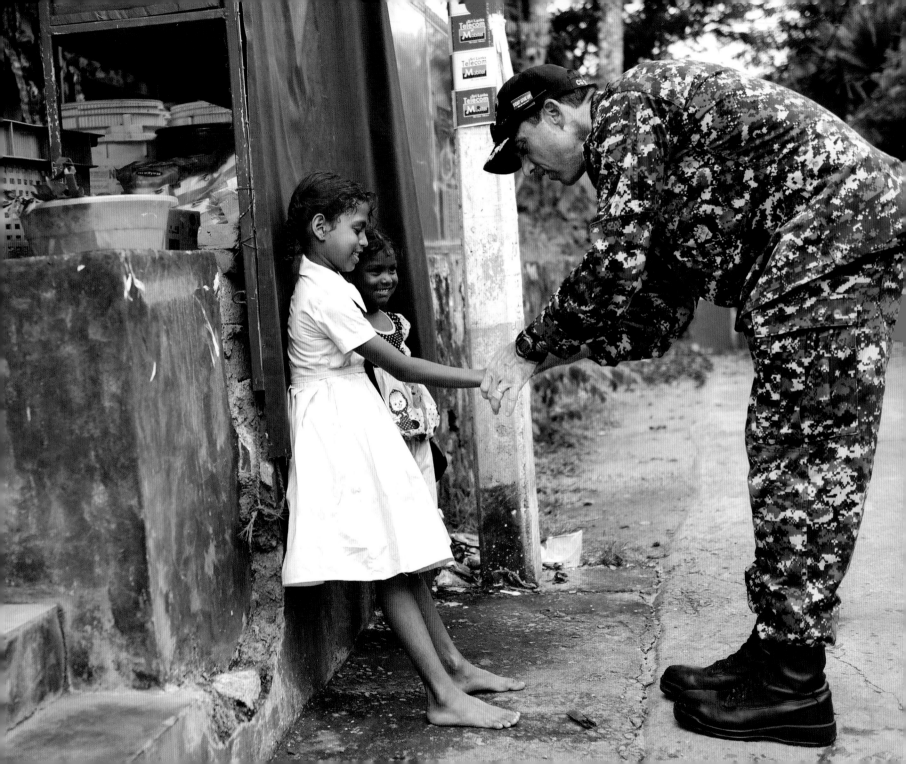

Real heroes don't wear capes;
they wear dog tags.

—UNKNOWN

May the sun in his course
visit no land

MORE FREE, MORE HAPPY, MORE LOVELY,

than this our own country!

—DANIEL WEBSTER

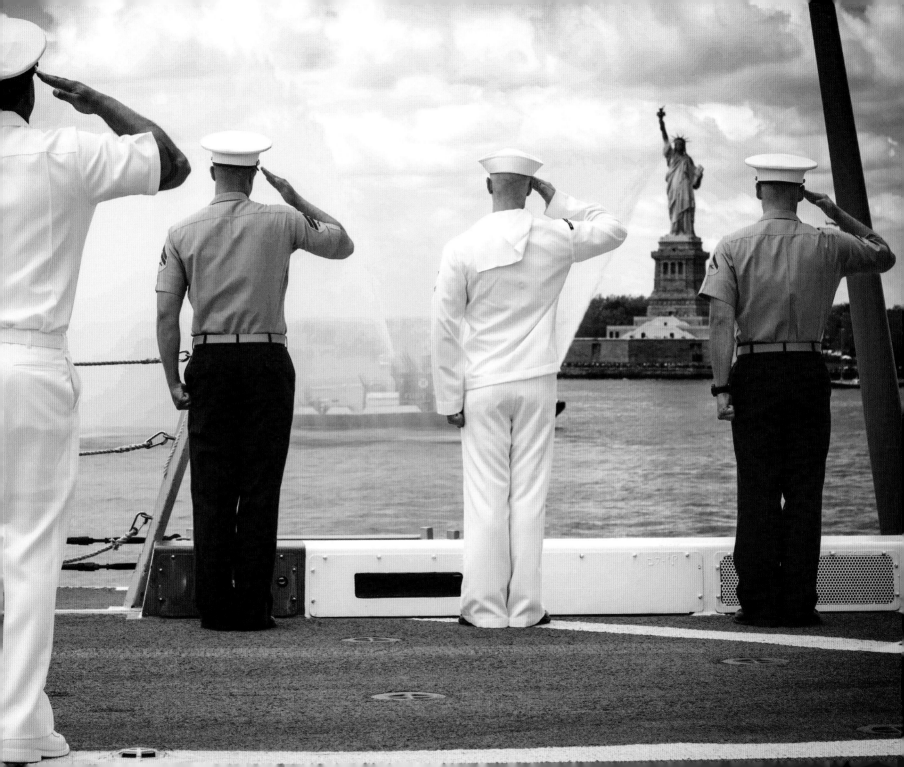

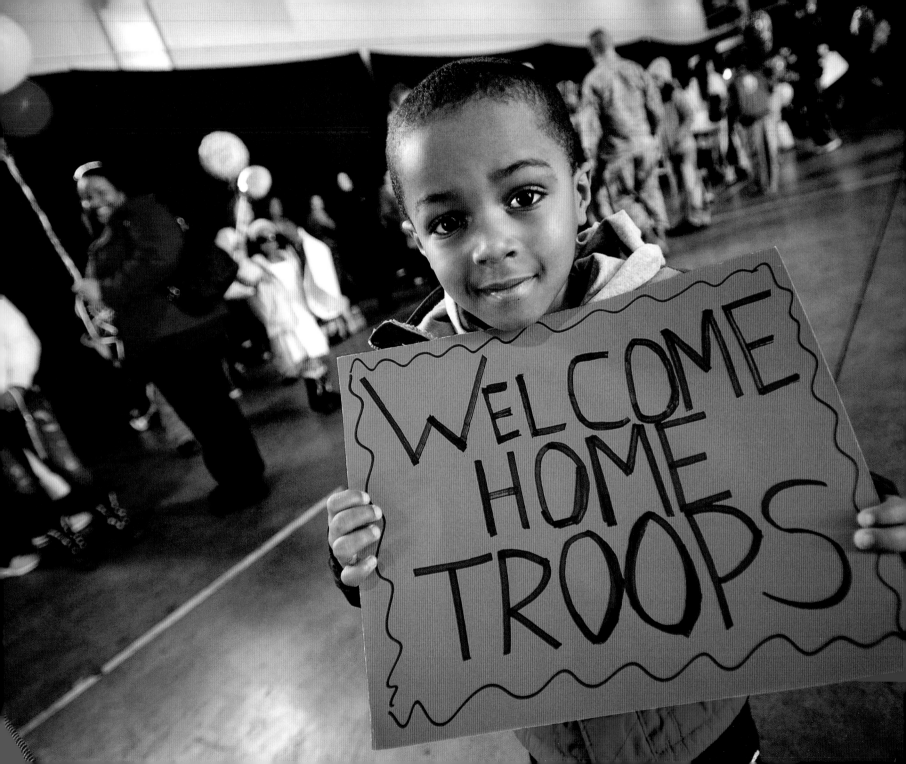

DREAMS CAN
grow wild
BORN INSIDE AN
American child.

—PHIL VASSAR

I can't claim to know the words
of all the national anthems
in the world, but I don't know of
any other that ends with a question
and a challenge as ours does:
Does that flag still wave
o'er the land of the free
and the home of the brave?
That is what we must all ask.

—RONALD REAGAN

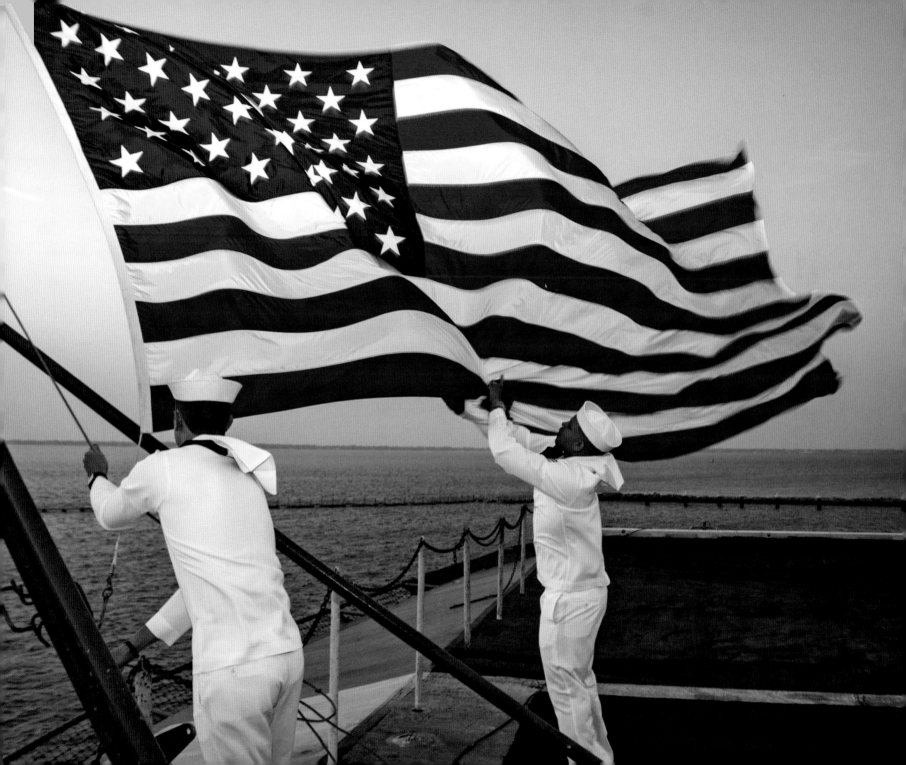

★ PHOTO CREDITS ★